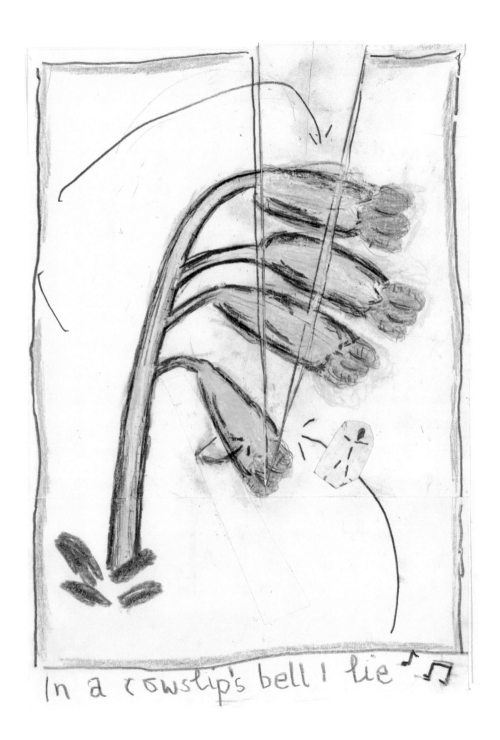

In a Cowslip's Bell I Lie

William
Shakespeare

Rose Wylie

The Tempest

By William Shakespeare
With a text by Katie Kitamura
Artwork by Rose Wylie

David Zwirner Books

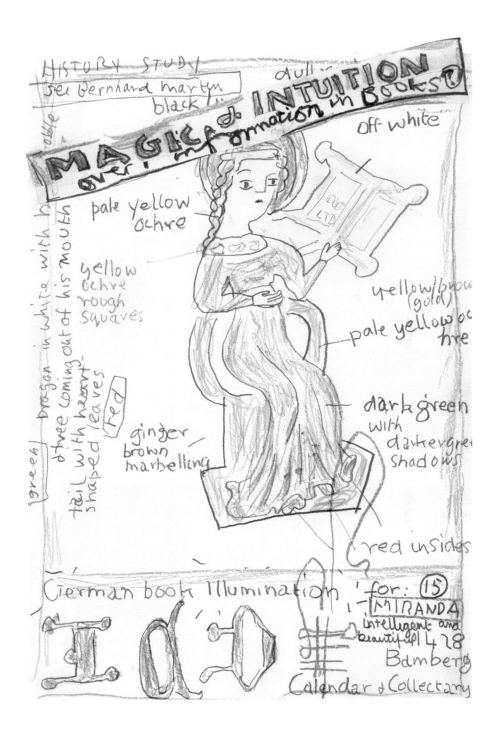

HISTORY STUDY
see Bernhard Martyn
black " dull

MAGIC & INTUITION over information in books?

off white

pale yellow ochre

yellow ochre rough squares

yellow/brow (gold)

pale yellow ochre

dragon in white with h
tree coming out of his mouth
tail with heart shaped leaves

green

Red

ginger brown marbelling

dark green with darker green shadows

red insides

German book Illumination

for: ⑮
MIRANDA
intelligent and beautiful 428
Bamberg
Calendar & Collectary

Magic & Intuition

The Inhabitants

Katie Kitamura

These, then, are the inhabitants of the island, these four.

Ariel

In this volume, there is a series of drawings of Ariel: *Arial as a Box of Matches*, Ariel as a "half-open" matchbox, winged and flipping through the air. In each drawing, there is a curling line to indicate the movement of the matchbox. The images work in unison, forming a flipbook of sorts. A reference to early cinema and, by extension, to time and memory.

The artist, Rose Wylie, tells me that time is central to her understanding of *The Tempest*. The play, she explains, exemplifies the Aristotelian unity of time. Memory is also important, because we experience temporality through it. I ask if she draws from memory, and she replies that although people often say her drawings and paintings are created in this way, strictly speaking, it isn't true. It's a combination, she explains, of recollection and source material.

She pauses. Then she tells me that in the case of these drawings, she relied almost completely on memory. She knew the play well, and the drawings were not, in any case, designed to act as illustrations. The drawings are hardly illustrative, it's true. And yet they are, to me, highly interpretive—or to be more precise, the drawings help me interpret and reorient my own relationship to the play.

For example, of the central characters, I've always found Ariel the least compelling. He lacks Caliban's charisma and corporeality, his longing and grief and rage. Ariel is light and air and surface. And yet the drawings remind us that Ariel is the character who first articulates the central concern of the play, one shared by Caliban: liberation.

Ariel speaks his demand for freedom at the very beginning of the play. Transformations occur throughout, but the most central one is the transformation from captivity to freedom. And of the various power struggles in the drama, the one between Prospero and the enslaved Ariel and Caliban is of greatest moral and dramatic urgency.

Prospero is a great manipulator of his own image, but from the very start, Ariel characterizes Prospero in no uncertain terms: as a tyrant with an edge of dishonesty, the embodiment of patriarchal control. Ariel also calls time on Prospero's rule, striking a bargain with the magician, who agrees to "discharge" him "after two days" if he does as he commands (I.ii.350–351).

In the drawings, Ariel takes the form of a matchbox, a tool for combustion. As if conflagration alone will break Prospero's iron grip. But there is one drawing of Ariel, more detailed than the others, in which he appears as a face in profile. The words at the bottom of the drawing read, "Arial about to turn into a matchbox." Elsewhere in the work are the words "magic" and "calm sea."

This particular portrait form is repeated across the drawings (Miranda's face in profile, Ferdinand's face in profile). But while those characters exude calm and placidity, Ariel's expression is one of agony and apprehension. There is a cost to all this transformation, it seems to say. In the bottom corner is an inanimate matchbox, which the spirit will animate. The matchbox comes to life, and the clock begins to tick.

Prospero

There are only two portraits of Prospero, and for a moment I make the mistake of thinking the character doesn't interest the artist. But as I sift through the work, it occurs to me that the drawings of the landscape, even of the storm that opens the play, might be taken as parts of the Prospero portrait. The map of the island, for example—the tool of the colonizer, converting the terrain into territory—is one expression of how Prospero creates the world around him.

Creates, and controls. We first meet him as a displaced ruler, but this narrative is one Prospero yields like a weapon—a grievance narrative that he uses to manipulate his daughter and introduce himself to the audience. In a play about transformation, Prospero can often appear as the still center, his authority granting him the appearance of fixity and permanence, the figure who controls the sea change around him.

But in reality, he is patriarchal authority in multiple guises, a figure of grievance, exile, and disavowal. A figure of paradox, at once rigid and shifting. The two portraits of Prospero—*Prospero as "Governor"* and *Prospero as Magician*—are designed for comparison, both mug shots of a kind. They are prime examples of the artist's ruthless efficiency, and in these two drawings she captures Prospero's character with brutal clarity.

In *Prospero as "Governor,"* the characterization is there in the mere outline of the jaw, elaborated in the line of the eyebrows, the cowlick of hair at the top. He is a tyrant, every inch the fascist, with a thick neck and a knee for a chin and the vanity of his sly elegance.

In *Prospero as Magician*, his face is as stiff as a Guy Fawkes mask, the contours harsh and decisive, the moustache and hairline now precise to the point of fanaticism. But the most telling detail of the portrait is the eyes—direct and off kilter, somehow shameless in their derangement. This, the artist seems to say, is where the tyranny of the first portrait always leads.

When I stare at these two faces for long enough, I think of the Sylvia Plath poem "Daddy":

> I have always been scared of *you*,
> With your Luftwaffe, your gobbledygoo.
> And your neat mustache
> And your Aryan eye, bright blue.

What are these faces if not:

> Marble-heavy, a bag full of God,
> Ghastly statue with one gray toe

These two heads:

> . . . in the freakish Atlantic
> Where it pours bean green over blue

Of course, Plath wrote another poem that is directly in dialogue with *The Tempest*, "Full Fathom Five." Another poem about a father, and a riff on Ariel's song about the other father in the play, Alonso, equally treacherous—the father and the brother—immortalized as follows:

> Full fathom five thy father lies.
> Of his bones are coral made.
> Those are pearls that were his eyes.
> Nothing of him that doth fade
> But doth suffer a sea change
> Into something rich and strange.
> (I.ii.462–467)

The artist's drawing features a line from Ariel's song and a grid of frames, tilted to create vertigo, at the center of which lies a skeleton. The play and the Plath poems, and, by extension, these images, are full of undead fathers, fathers who refuse to be killed or to stay dead (Alonso is not, of course, actually dead, his announced demise a manipulation). The undead father terrorizes his children, literal and symbolic. At the end of "Daddy," Plath invokes a group of villagers, long subordinated, giddy with the final death of the father:

> There's a stake in your fat black heart
> They are dancing and stamping on you.
> They always *knew* it was you.

This is a description of release, and relief. But I wonder how much of that relief also belongs to the father. The Prospero drawings reveal the structure of patriarchal authority. The carapace concealing the soft underside of mutability. In the end, it is easy to imagine that there might be relief in shedding that casing and letting the mantle of authority drop to the ground.

 We know Prospero as a magician, of course. A creator, a stand-in for the author. We know him also as an enslaver (see Ariel, above, and Caliban, below). But, and this is perhaps the point, there is no way to know him as these things without also knowing him as a father (see Miranda, below).

Miranda

The artist's drawings of Prospero, despite the cleanness of the lines, are not especially simple. The drawings are detailed, and the gap between the two portraits is especially complex. By contrast, the drawings of Miranda really are simple, although like the drawings of her father, they are also images of transformation.

There are more drawings of Miranda than any other character, and like those of Ariel as a matchbox, the bulk of these images work in sequence. On some level, the transformation across the drawings is more transparent, the measurements of growth and time clearly articulated and then rearticulated in the images and in the text, which in one painting reads, "Miranda used as a ticking clock device for passing time."

Miranda is the ticking clock, perhaps because of all the characters in the play, she is the one most clearly oriented to the future. Caliban and Ariel desire a return to the past (the recovery of their lost freedom). Prospero is also engaged in an act of restoration. But Miranda greets this "brave new world / That has such people in 't!" (V.i.206–207). Time has meaning for Miranda, who has for so long been sequestered from company, her life circumscribed by her father.

From the beginning, Miranda is manipulated by Prospero, by devices both human and magical. Her encounter with Ferdinand is orchestrated, her emotion schematized, turned inside out and exposed. But in these drawings, Miranda is rendered opaque. Her back is to the viewer, her face concealed. Here, in these sheets of paper, her privacy is restored.

We are given only the square of her shoulders, the back of her head, the occasional limb, always growing and growing and growing. She sits in a pink dress, engaged in private tasks: in one, conducting an orchestra, in another collecting leaves. She is often sitting in a chair, at times disproportionately small, at other times disproportionately large, so that I think of other young and clever girls surrounded by beasts and fluctuating in size—Alice, Goldilocks.

Most mysterious of all is Miranda as she appears in the two-panel painting at the heart of this work. Dark-Haired Miranda inside Light-Haired Miranda. The text tells us that Dark-Haired Miranda is "mostly hidden in her favourite chair" and is three years old, her age

when she arrives on the island with Prospero. Dark-Haired Miranda is tucked inside Light-Haired Miranda, fifteen years old, her age at the time of the play's action.

The image makes me think of the trunk of a tree, the young sapling concealed inside the mature tree, the rings of the tree a record of time passing. But then I remember that Ariel was similarly confined by Sycorax:

> Into a cloven pine, within which rift
> Imprisoned thou didst painfully remain
> A dozen years . . .
> (I.ii.325–327)

The same image structure, the same dozen years. I don't know if the artist is drawing a parallel between Miranda and Ariel, or if this synchronicity is only coincidence, of the kind that often emerges when you set two bodies of work alongside one another. You can fall into a fever dream of interpretation.

Meanwhile, the other panel features Caliban, reclining on a sofa, underneath a spotlight, "a man" (and not, the painting seems to say, a monster) "on a sofa."

Interlude

I receive a message from the artist, who has read a draft of this essay. To my relief, she tells me that she is happy with the text, but has one note: Where is her drawing of Ferdinand? I remember that we spoke about this portrait at length, about her efforts to render him as modern as possible, so that "a young woman looking at him now might feel what Miranda feels."

"Dishy" was the exact word she used. In her message, she explains that the line quality of Ferdinand's face echoes Prospero's, and when I go back and compare the two drawings I see the parallel—critical, the artist says, in establishing Ferdinand's so-called suitability to both Miranda and Prospero. She mentions that it was important to find a way to separate Ferdinand from Caliban—Caliban, who is "viable" but not "suitable."

Caliban

There are two drawings of Caliban. The first is the two-panel painting referenced above, *Miranda, Twice and Caliban*. The second is a drawing of Caliban, his shape a near geometric abstraction, rising out of the water, *Caliban as a Viable and Practical Man*. Fishing, the artist tells me. She wanted to portray him not as a monster, but as a man of competence and ability. A viable man.

There is also a portrait of his mother, the witch Sycorax, and it is one of the most detailed images in this volume. Unlike the omnipresent fathers, the mothers in *The Tempest* do not appear on stage and Miranda's mother, in particular, is barely mentioned. Sycorax is somewhat different. Prospero refers to her again and again, perhaps because she is one of the few characters in the world of the play who can match him for cunning and power.

Sycorax makes me think of that other literary mother of a so-called monster, Grendel's mother (who, unlike Sycorax, is never named, never referred to as anything other than mother). Like Grendel, Caliban is among the handful of literary characters who exist in the imagination beyond their originating story, who inspire secondary and tertiary works—Mrs. Rochester from *Jane Eyre*, Friday from *Robinson Crusoe*.

In their originating stories, these characters are pushed off the page and into the attic. They are often silenced, or near enough. This is in part because of who they are—women, the colonized and enslaved—and in part because of the danger to power they represent. They are destabilizing forces, characters with a moral claim, characters who have been wronged by those in power.

They are characters who tilt a story away from its (ostensible) center. I have always thought of *The Tempest* as Caliban's play. He is the character who fascinates, and he is the nexus of the play's ethical inquiry. Caliban's claim to the island is stronger than Prospero's, and his story is grounded in histories that are all too real. To read the play, written in the early years of the seventeenth century, a period of territorial expansion, through the lens of imperialism is simply to read what is there.

But Caliban, unlike Grendel, is far from silent. This brutalized and brutalizing figure speaks some of the richest language of the

play. Within the constructed world of a play, the character with access to language is the character with access to dignity, the character who claims space and captures the audience's sympathy. Some of the language that is most strongly associated with the play belongs to Caliban.

There is a schism between the character's biography as we understand it and the language that he speaks. In *Caliban Codex* (1992), Jimmie Durham reimagines Caliban by recalibrating his relationship to language. While Shakespeare's Caliban possesses tremendous linguistic facility, Durham's Caliban undergoes a stuttering and gradual apprehension of language. His rage lacks fluid expression, emerging in fits and starts. Most powerfully, he fumbles toward self-articulation, only to comprehend how thoroughly Prospero has negated that possibility: "I don't know what I look like. Since Dr. Prospero came there's nothing here that reflects me."

If Caliban feels supremely modern as a character, then I think that is because in his character the nature of language is most strongly felt. Language is a form of power, a tool of domination and restriction. Caliban speaks the language of the colonizer, against his will.

> You taught me language, and my profit on 't
> Is I know how to curse. The red plague rid you
> For learning me your language!
> (I.ii.425–427)

Prospero teaches him "how / To name the bigger light and how the less" (I.ii.394–395), but only as a prelude to seizing the island. From that point onward, the language that Caliban cannot help but speak is freighted with bitterness. His is the language that is heaviest with loss and also with longing. In what is perhaps Caliban's most famous speech, and one of the most famous speeches in the play more generally, what he describes is not language, but noise and sound and music.

> Be not afeard. The isle is full of noises,
> Sounds and sweet airs that give delight and hurt not.
> Sometimes a thousand twangling instruments

Will hum about mine ears, and sometimes voices
That, if I then had waked after long sleep,
Will make me sleep again; and then, in dreaming,
The clouds methought would open, and show riches
Ready to drop upon me, that when I waked
I cried to dream again.
(III.ii.130–138)

That noise is what he wants to return to, the isle before the others
arrived.

Those are the figures. There are also drawings of the terrain, the
green and the blue that denote a vast expanse of land and water.
The terrain that is disputed, stolen, claimed, the place that created
these characters. In one, I notice a small shape in the middle of a
wash of blue. The text running at the bottom of the drawing reads:
"Time 12 years earlier. The island. First spotted by Prospero 12 years
earlier." And I understand that in taking in that vast wash of water,
I am inhabiting Prospero's perspective, his point of view.

But then there is another drawing, similar but entirely
different—a nugget of black in the middle of a field of meadow
green. And this time, Prospero is not written into the drawing. There
are only two words: "The Island." The drawing indicates a scale,
a landscape, that eludes even Prospero's grasp. It invokes everything
that cannot be contained by the map. Even here, it seems to say,
there are places he cannot go.

The
Tempest

Characters in the play

PROSPERO, the right Duke of Milan
MIRANDA, daughter to Prospero
ARIEL, an airy spirit
CALIBAN, servant to Prospero

FERDINAND, Prince of Naples
ALONSO, King of Naples
ANTONIO, Duke of Milan and brother to Prospero
SEBASTIAN, brother to Alonso
GONZALO, councilor to Alonso and friend to Prospero
Lords in attendance on Alonso:
 ADRIAN
 FRANCISCO

TRINCULO, servant to Alonso
STEPHANO, butler to Alonso

SHIPMASTER
BOATSWAIN
MARINERS

PLAYERS WHO, AS SPIRITS, TAKE THE ROLES OF IRIS, CERES, JUNO,
NYMPHS, AND REAPERS IN PROSPERO'S MASQUE, AND WHO, IN OTHER
SCENES, TAKE THE ROLES OF "ISLANDERS" AND OF HUNTING DOGS

Act 1.

Scene 1.
On a ship at sea

[*A tempestuous noise of thunder and lightning heard. Enter a Shipmaster and a Boatswain.*]

MASTER Boatswain!

BOATSWAIN Here, master. What cheer?

MASTER Good,* speak to th' mariners. Fall to 't yarely,* *Good fellow | briskly*
or we run ourselves aground. Bestir, bestir! [*He exits.*]

[*Enter Mariners.*]

5 BOATSWAIN Heigh, my hearts! Cheerly, cheerly, my hearts! Yare,
yare! Take in the topsail. Tend to th' master's whistle. Blow till thou
burst thy wind, if room enough!

[*Enter Alonso, Sebastian, Antonio, Ferdinand, Gonzalo, and others.*]

ALONSO Good boatswain, have care. Where's the master? Play* *Act like*
the men.

10 BOATSWAIN I pray now, keep below.

ANTONIO Where is the master, bos'n?

BOATSWAIN Do you not hear him? You mar our labor. Keep your
cabins; you do assist the storm.

GONZALO Nay, good, be patient.

15 BOATSWAIN When the sea is. Hence! What cares these roarers for
the name of king? To cabin! Silence! Trouble us not.

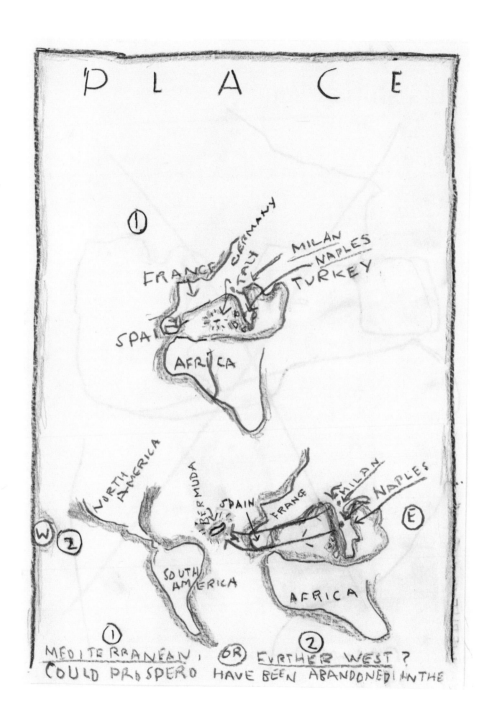

GONZALO Good, yet remember whom thou hast aboard.

BOATSWAIN None that I more love than myself. You are a councilor;
if you can command these elements to silence, and work the peace
of the present,* we will not hand* a rope more. Use your authority. *restore peace | handle*
If you cannot, give thanks you have lived so long, and make yourself
ready in your cabin for the mischance of the hour, if it so hap.
Cheerly, good hearts! Out of our way, I say. [*He exits.*]

GONZALO I have great comfort from this fellow. Methinks he hath
no drowning mark upon him. His complexion is perfect gallows.
Stand fast, good Fate, to his hanging. Make the rope of his destiny
our cable, for our own doth little advantage. If he be not born to be
hanged, our case is miserable.

[*Gonzalo exits with Alonso, Sebastian, and the other courtiers.
Enter Boatswain.*]

BOATSWAIN Down with the topmast! Yare! Lower, lower! Bring
her to try with main course.* [*A cry within.*] A plague upon this *Heave to*
howling! They* are louder than the weather or our office.* *The passengers | us at work*
[*Enter Sebastian, Antonio, and Gonzalo.*] Yet again? What do you
here? Shall we give o'er* and drown? Have you a mind to sink? *give up*

SEBASTIAN A pox o' your throat, you bawling, blasphemous,
incharitable dog!

BOATSWAIN Work you, then.

ANTONIO Hang, cur, hang, you whoreson, insolent noisemaker!
We are less afraid to be drowned than thou art.

GONZALO I'll warrant him for* drowning, though the ship were *guarantee him against*
no stronger than a nutshell and as leaky as an unstanched* wench. *wide open*

BOATSWAIN Lay her ahold, ahold! Set her two courses. Off to sea
again! Lay her off!* *away from shore*

[*Enter more Mariners, wet.*]

MARINERS All lost! To prayers, to prayers! All lost! [*They exit.*]

BOATSWAIN What, must our mouths be cold?

45 GONZALO The King and Prince at prayers. Let's assist them,
For our case is as theirs.

SEBASTIAN I am out of patience.

ANTONIO We are merely* cheated of our lives by drunkards. *completely*
This wide-chopped* rascal—would thou mightst lie drowning *big-mouthed*
50 The washing of ten tides!

GONZALO He'll be hanged yet,
Though every drop of water swear against it
And gape at wid'st to glut him.

[*A confused noise within.*] "Mercy on us!"—
55 "We split, we split!"—"Farewell, my wife and children!"—
"Farewell, brother!"—"We split, we split, we split!"

[*Boatswain exits.*]

ANTONIO Let's all sink wi' th' King.

SEBASTIAN Let's take leave of him.
[*He exits with Antonio.*]

GONZALO Now would I give a thousand furlongs of sea for an acre
60 of barren ground: long heath,* brown furze, anything. The wills above *heather*
be done, but I would fain die a dry death.

[*He exits.*]

Scene 2.
The island. In front of Prospero's cell

[*Enter Prospero and Miranda.*]

MIRANDA If by your art, my dearest father, you have
Put the wild waters in this roar, allay them.
The sky, it seems, would pour down stinking pitch,
But that the sea, mounting to th' welkin's cheek,* *face of the sky*
5 Dashes the fire out. O, I have suffered
With those that I saw suffer! A brave* vessel *fine, handsome*
(Who had, no doubt, some noble creature in her)
Dashed all to pieces! O, the cry did knock
Against my very heart! Poor souls, they perished.
10 Had I been any god of power, I would
Have sunk the sea within the earth or ere
It should the good ship so have swallowed and
The fraughting souls* within her. *cargo*

PROSPERO Be collected.
15 No more amazement.* Tell your piteous heart *consternation*
There's no harm done.

MIRANDA O, woe the day!

PROSPERO No harm.
I have done nothing but in care of thee,
20 Of thee, my dear one, thee, my daughter, who
Art ignorant of what thou art, naught knowing
Of whence I am, nor that I am more better
Than Prospero, master of a full poor cell,
And thy no greater father.

25 MIRANDA More to know
Did never meddle* with my thoughts. *mingle*

PROSPERO 'Tis time
I should inform thee farther. Lend thy hand
And pluck my magic garment from me. So,
[*Puts aside his cloak.*]
30 Lie there, my art. Wipe thou thine eyes. Have comfort.
The direful spectacle of the wrack, which touched
The very virtue* of compassion in thee, *essence*
I have with such provision* in mine art *foresight*
So safely ordered that there is no soul—
35 No, not so much perdition* as an hair *loss*
Betid* to any creature in the vessel *Happened*
Which thou heard'st cry, which thou saw'st sink. Sit down,
For thou must now know farther.

MIRANDA You have often
40 Begun to tell me what I am, but stopped
And left me to a bootless inquisition,
Concluding "Stay. Not yet."

PROSPERO The hour's now come.
The very minute bids thee ope thine ear.
45 Obey,* and be attentive. Canst thou remember *Listen*
A time before we came unto this cell?
I do not think thou canst, for then thou wast not
Out* three years old. *Fully*

MIRANDA Certainly, sir, I can.

50 PROSPERO By what? By any other house or person?
Of anything the image tell me that
Hath kept with thy remembrance.

MIRANDA 'Tis far off
And rather like a dream than an assurance
55 That my remembrance warrants.* Had I not *memory guarantees*
Four or five women once that tended me?

CRU JUL

MIRANDA AGED 3

Miranda with Yellow Hair Blowing Left

M. VERY YOUNG
LATE NIGHT

(collecting leaves)

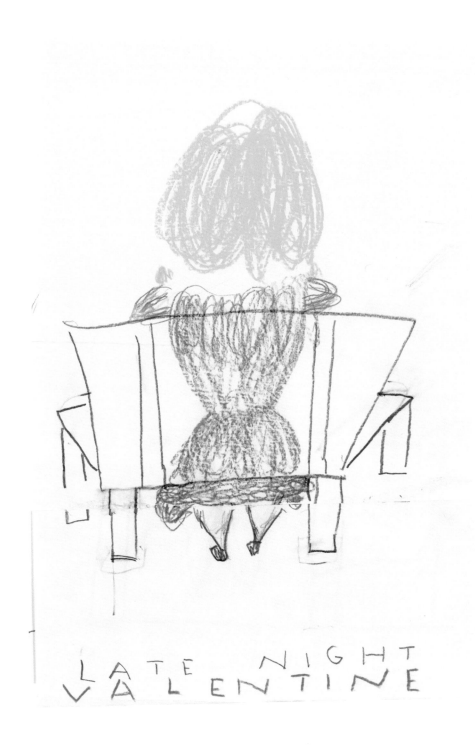

LATE NIGHT VALENTINE

Miranda Aged 4

M I R A N D A
AGED 3

Miranda on a Green Chair

PROSPERO Thou hadst, and more, Miranda. But how is it
That this lives in thy mind? What seest thou else
In the dark backward and abysm of time?
60 If thou rememb'rest aught ere thou cam'st here,
How thou cam'st here thou mayst.

MIRANDA But that I do not.

PROSPERO Twelve year since, Miranda, twelve year since,
Thy father was the Duke of Milan and
65 A prince of power.

MIRANDA Sir, are not you my father?

PROSPERO Thy mother was a piece* of virtue, and *masterpiece*
She said thou wast my daughter. And thy father
Was Duke of Milan, and his only heir
70 And princess no worse issued.* *of no meaner descent*

MIRANDA O, the heavens!
What foul play had we that we came from thence?
Or blessèd was 't we did?

PROSPERO Both, both, my girl.
75 By foul play, as thou sayst, were we heaved thence,
But blessedly holp* hither. *helped*

MIRANDA O, my heart bleeds
To think o' th' teen* that I have turned you to,* *trouble / caused you to remember*
Which is from my remembrance! Please you, farther.

80 PROSPERO My brother and thy uncle, called Antonio—
I pray thee, mark me—that a brother should
Be so perfidious!—he whom next thyself
Of all the world I loved, and to him put
The manage* of my state,* as at that time *management / domain*
85 Through all the signories* it was the first, *lordships*
And Prospero the prime duke, being so reputed

In dignity, and for the liberal arts
Without a parallel. Those being all my study,
The government I cast upon my brother
90 And to my state grew stranger, being transported
And rapt in secret studies. Thy false uncle—
Dost thou attend me?

MIRANDA Sir, most heedfully.

PROSPERO Being once perfected* how to grant suits, *grown skillful*
95 How to deny them, who t' advance, and who
To trash for overtopping, new created
The creatures* that were mine, I say, or changed 'em, *followers*
Or else new formed 'em, having both the key
Of officer and office, set all hearts i' th' state
100 To what tune pleased his ear, that now he was
The ivy which had hid my princely trunk
And sucked my verdure out on 't. Thou attend'st not.

MIRANDA O, good sir, I do.

PROSPERO I pray thee, mark me.
105 I, thus neglecting worldly ends, all dedicated
To closeness* and the bettering of my mind *seclusion*
With that which, but by being so retired,
O'erprized all popular rate, in my false brother
Awaked an evil nature, and my trust,
110 Like a good parent, did beget of him
A falsehood in its contrary as great
As my trust was, which had indeed no limit,
A confidence sans bound.* He being thus lorded, *unlimited*
Not only with what my revenue yielded
115 But what my power might else exact, like one
Who, having into truth by telling of it,* *the lie*
Made such a sinner of his memory
To* credit his own lie, he did believe *As to*
He was indeed the Duke, out o' th' substitution
120 And executing th' outward face of royalty

With all prerogative. Hence, his ambition growing—
Dost thou hear?

MIRANDA Your tale, sir, would cure deafness.

PROSPERO To have no screen between this part he played
125 And him he played it for, he needs will be
Absolute Milan.* Me, poor man, my library *Duke of Milan*
Was dukedom large enough. Of temporal royalties
He thinks me now incapable; confederates
(So dry* he was for sway) wi' th' King of Naples *thirsty*
130 To give him annual tribute, do him homage,
Subject his coronet to his crown, and bend
The dukedom, yet unbowed (alas, poor Milan!)
To most ignoble stooping.

MIRANDA O, the heavens!

135 PROSPERO Mark his condition* and th' event.* Then tell me *pact* / *outcome*
If this might be a brother.

MIRANDA I should sin
To think but nobly of my grandmother.
Good wombs have borne bad sons.

140 PROSPERO Now the condition.
This King of Naples, being an enemy
To me inveterate, hearkens my brother's suit,
Which was that he, in lieu o' th' premises* *in return for guarantees*
Of homage and I know not how much tribute,
145 Should presently extirpate me and mine
Out of the dukedom, and confer fair Milan,
With all the honors, on my brother. Whereon,
A treacherous army levied, one midnight
Fated to th' purpose did Antonio open
150 The gates of Milan, and i' th' dead of darkness
The ministers* for th' purpose hurried thence *agents*
Me and thy crying self.

MIRANDA Alack, for pity!
I, not rememb'ring how I cried out then,
Will cry it o'er again. It is a hint* *occasion*
That wrings mine eyes to 't.

PROSPERO Hear a little further,
And then I'll bring thee to the present business
Which now 's upon 's, without the which this story
Were most impertinent.* *inappropriate*

MIRANDA Wherefore did they not
That hour destroy us?

PROSPERO Well demanded, wench.
My tale provokes that question. Dear, they durst not,
So dear the love my people bore me, nor set
A mark so bloody on the business, but
With colors fairer painted their foul ends.
In few,* they hurried us aboard a bark, *few words*
Bore us some leagues to sea, where they prepared
A rotten carcass of a butt,* not rigged, *tub*
Nor tackle, sail, nor mast; the very rats
Instinctively have quit it. There they hoist us
To cry to th' sea that roared to us, to sigh
To th' winds, whose pity, sighing back again,
Did us but loving wrong.

MIRANDA Alack, what trouble
Was I then to you!

PROSPERO O, a cherubin
Thou wast that did preserve me. Thou didst smile,
Infusèd with a fortitude from heaven,
When I have decked the sea with drops full salt,* *cried into the sea*
Under my burden groaned, which* raised in me *(Miranda's smile)*
An undergoing stomach* to bear up *resolution*
Against what should ensue.

185 MIRANDA How came we ashore?

PROSPERO By providence divine.
Some food we had, and some fresh water, that
A noble Neapolitan, Gonzalo,
Out of his charity, who being then appointed
190 Master of this design, did give us, with
Rich garments, linens, stuffs, and necessaries,
Which since have steaded* much. So, of his gentleness, *been of use
Knowing I loved my books, he furnished me
From mine own library with volumes that
195 I prize above my dukedom.

MIRANDA Would I might
But ever see that man.

PROSPERO Now I arise.
Sit still, and hear the last of our sea sorrow.
200 Here in this island we arrived, and here
Have I, thy schoolmaster, made thee more profit
Than other princess' can,* that have more time *can have
For vainer hours and tutors not so careful.

MIRANDA Heavens thank you for 't. And now I pray you, sir—
205 For still 'tis beating in my mind—your reason
For raising this sea storm?

PROSPERO Know thus far forth:
By accident most strange, bountiful Fortune
(Now my dear lady*) hath mine enemies *(formerly foe)
210 Brought to this shore; and by my prescience
I find my zenith* doth depend upon *apex of fortune
A most auspicious star, whose influence
If now I court not, but omit,* my fortunes *neglect
Will ever after droop. Here cease more questions.
215 Thou art inclined to sleep. 'Tis a good dullness,
And give it way. I know thou canst not choose.
[*Miranda sleeps.*]

Come away,* servant, come! I am ready now. *Come here*
Approach, my Ariel! Come!

[*Enter Ariel.*]

ARIEL All hail, great master! Grave sir, hail! I come
220 To answer thy best pleasure. Be 't to fly,
To swim, to dive into the fire, to ride
On the curled clouds, to thy strong bidding task
Ariel and all his quality.* *cohorts*

PROSPERO Hast thou, spirit,
225 Performed to point* the tempest that I bade thee? *in detail*

ARIEL To every article.
I boarded the King's ship; now on the beak,* *prow*
Now in the waist,* the deck,* in every cabin, *middle / poop deck*
I flamed amazement.* Sometimes I'd divide *struck terror (as St. Elmo's fire)*
230 And burn in many places. On the topmast,
The yards, and boresprit* would I flame distinctly,* *bowsprit / in different places*
Then meet and join. Jove's lightning, the precursors
O' th' dreadful thunderclaps, more momentary
And sight-outrunning were not. The fire and cracks
235 Of sulfurous roaring the most mighty Neptune
Seem to besiege and make his bold waves tremble,
Yea, his dread trident shake.

PROSPERO My brave spirit!
Who was so firm, so constant, that this coil* *uproar*
240 Would not infect his reason?

ARIEL Not a soul
But felt a fever of the mad, and played
Some tricks of desperation. All but mariners
Plunged in the foaming brine and quit the vessel,
245 Then all afire with me. The King's son Ferdinand,
With hair up-staring* (then like reeds, not hair), *standing on end*
Was the first man that leaped; cried "Hell is empty,
And all the devils are here."

34

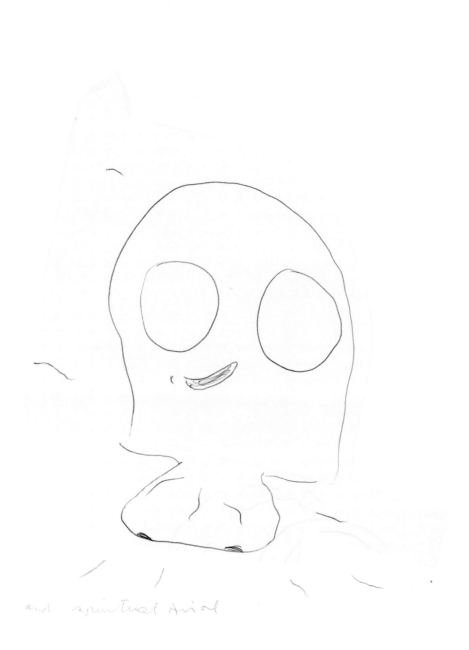

and spiritual Arial

Arial as a Spirit

35

PROSPERO Why, that's my spirit!
250 But was not this nigh shore?

ARIEL Close by, my master.

PROSPERO But are they, Ariel, safe?

ARIEL Not a hair perished.
On their sustaining* garments not a blemish, *buoying them up*
255 But fresher than before; and, as thou bad'st me,
In troops I have dispersed them 'bout the isle.
The King's son have I landed by himself,
Whom I left cooling of the air with sighs
In an odd angle of the isle, and sitting,
260 His arms in this sad knot. [*He folds his arms.*]

PROSPERO Of the King's ship,
The mariners say how thou hast disposed,
And all the rest o' th' fleet.

ARIEL Safely in harbor
265 Is the King's ship; in the deep nook, where once
Thou called'st me up at midnight to fetch dew
From the still-vexed Bermoothes,* there she's hid; *Bermudas*
The mariners all under hatches stowed,
Who, with a charm joined to their suff'red* labor, *undergone*
270 I have left asleep. And for the rest o' th' fleet,
Which I dispersed, they all have met again
And are upon the Mediterranean flote,* *sea*
Bound sadly home for Naples,
Supposing that they saw the King's ship wracked
275 And his great person perish.

PROSPERO Ariel, thy charge
Exactly is performed. But there's more work.
What is the time o' th' day?

ARIEL Past the mid season.* *noon*

PROSPERO At least two glasses.* The time 'twixt six and now *two o'clock*
280 Must by us both be spent most preciously.

ARIEL Is there more toil? Since thou dost give me pains,* *hard tasks*
Let me remember* thee what thou hast promised, *remind*
Which is not yet performed me.

PROSPERO How now? Moody?
285 What is 't thou canst demand?

ARIEL My liberty.

PROSPERO Before the time be out? No more.

ARIEL I prithee,
290 Remember I have done thee worthy service,
Told thee no lies, made no mistakings, served
Without or grudge or grumblings. Thou did promise
To bate me* a full year. *shorten my term of service*

PROSPERO Dost thou forget
295 From what a torment I did free thee?

ARIEL No.

PROSPERO Thou dost, and think'st it much to tread the ooze
Of the salt deep,
To run upon the sharp wind of the North,
300 To do me business in the veins* o' th' earth *streams*
When it is baked* with frost. *hardened*

ARIEL I do not, sir.

PROSPERO Thou liest, malignant thing. Hast thou forgot
The foul witch Sycorax, who with age and envy* *malice*
305 Was grown into a hoop? Hast thou forgot her?

ARIEL No, sir.

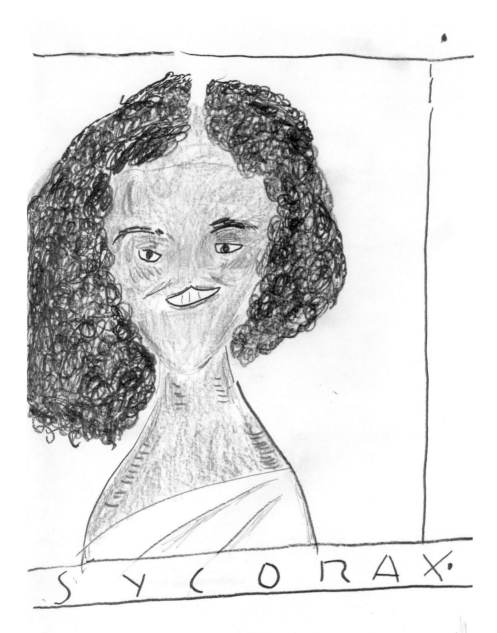

SYCORAX.

CALIBAN'S MOTHER . CLOSE-UP

Sycorax, Caliban's Mother, Close Up

PROSPERO Thou hast. Where was she born? Speak. Tell me.

ARIEL Sir, in Argier.* *Algiers*

PROSPERO O, was she so? I must
310 Once in a month recount what thou hast been,
 Which thou forget'st. This damned witch Sycorax,
 For mischiefs manifold, and sorceries terrible
 To enter human hearing, from Argier,
 Thou know'st, was banished. For one thing she did
315 They would not take her life. Is not this true?

ARIEL Ay, sir.

PROSPERO This blue-eyed hag was hither brought with child
 And here was left by th' sailors. Thou, my slave,
 As thou report'st thyself, wast then her servant,
320 And for thou wast a spirit too delicate
 To act her earthy and abhorred commands,
 Refusing her grand hests,* she did confine thee, *commands*
 By help of her more potent ministers* *agents*
 And in her most unmitigable rage,
325 Into a cloven pine, within which rift
 Imprisoned thou didst painfully remain
 A dozen years; within which space she died
 And left thee there, where thou didst vent thy groans
 As fast as mill wheels strike. Then was this island
330 (Save for the son that she did litter here,
 A freckled whelp, hag-born) not honored with
 A human shape.

ARIEL Yes, Caliban, her son.

PROSPERO Dull thing, I say so; he, that Caliban
335 Whom now I keep in service. Thou best know'st
 What torment I did find thee in. Thy groans
 Did make wolves howl, and penetrate the breasts
 Of ever-angry bears. It was a torment

To lay upon the damned, which Sycorax
340 Could not again undo. It was mine art,
When I arrived and heard thee, that made gape
The pine and let thee out.

ARIEL I thank thee, master.

PROSPERO If thou more murmur'st, I will rend an oak
345 And peg thee in his* knotty entrails till *its*
Thou hast howled away twelve winters.

ARIEL Pardon, master.
I will be correspondent* to command *obedient*
And do my spriting gently.* *graciously*

350 PROSPERO Do so, and after two days
I will discharge thee.

ARIEL That's my noble master.
What shall I do? Say, what? What shall I do?

PROSPERO Go make thyself like a nymph o' th' sea. Be subject
355 To no sight but thine and mine, invisible
To every eyeball else. Go, take this shape,
And hither come in 't. Go, hence with diligence!
[*Ariel exits.*] Awake, dear heart, awake. Thou hast slept well.
Awake. [*Miranda wakes.*]

360 MIRANDA The strangeness of your story put
Heaviness in me.

PROSPERO Shake it off. Come on,
We'll visit Caliban, my slave, who never
Yields us kind answer.

365 MIRANDA 'Tis a villain, sir,
I do not love to look on.

PROSPERO But, as 'tis,
We cannot miss* him. He does make our fire, *do without*
Fetch in our wood, and serves in offices
370 That profit us.—What ho, slave, Caliban!
Thou earth, thou, speak!

CALIBAN [*Within*] There's wood enough within.

PROSPERO Come forth, I say. There's other business for thee.
Come, thou tortoise. When?* *(expression of impatience)*
[*Enter Ariel like a water nymph.*]
375 Fine apparition! My quaint* Ariel, *ingenious*
Hark in thine ear. [*He whispers to Ariel.*]

ARIEL My lord, it shall be done. [*He exits.*]

PROSPERO Thou poisonous slave, got by the devil himself
Upon thy wicked dam, come forth!

[*Enter Caliban.*]

380 CALIBAN As wicked dew as e'er my mother brushed
With raven's feather from unwholesome fen
Drop on you both! A southwest blow on you
And blister you all o'er!

PROSPERO For this, be sure, tonight thou shalt have cramps,
385 Side-stitches that shall pen thy breath up. Urchins* *Hedgehogs*
Shall forth at vast* of night that they may work* *void | (belief that spirits work in darkness)*
All exercise on thee. Thou shalt be pinched
As thick as honeycomb, each pinch more stinging
Than bees that made 'em.

390 CALIBAN I must eat my dinner.
This island's mine by Sycorax, my mother,
Which thou tak'st from me. When thou cam'st first,
Thou strok'st me and made much of me, wouldst give me
Water with berries in 't, and teach me how

395 To name the bigger light and how the less,
That burn by day and night. And then I loved thee,
And showed thee all the qualities o' th' isle,
The fresh springs, brine pits, barren place and fertile.
Cursed be I that did so! All the charms
400 Of Sycorax—toads, beetles, bats, light on you!
For I am all the subjects that you have,
Which first was mine own king; and here you sty me
In this hard rock, whiles you do keep from me
The rest o' th' island.

405 PROSPERO Thou most lying slave,
Whom stripes* may move, not kindness, I have used thee *lashes*
(Filth as thou art) with humane care, and lodged thee
In mine own cell, till thou didst seek to violate
The honor of my child.

410 CALIBAN O ho, O ho! Would 't had been done!
Thou didst prevent me. I had peopled else
This isle with Calibans.

MIRANDA Abhorrèd slave,
Which any print of goodness wilt not take,
415 Being capable of all ill!* I pitied thee, *evil*
Took pains to make thee speak, taught thee each hour
One thing or other. When thou didst not, savage,
Know thine own meaning, but wouldst gabble like
A thing most brutish, I endowed thy purposes
420 With words that made them known. But thy vile race,* *nature*
Though thou didst learn, had that in 't which good natures
Could not abide to be with. Therefore wast thou
Deservedly confined into this rock,
Who hadst deserved more than a prison.

425 CALIBAN You taught me language, and my profit on 't
Is I know how to curse. The red plague* rid you *bubonic plague*
For learning me your language!

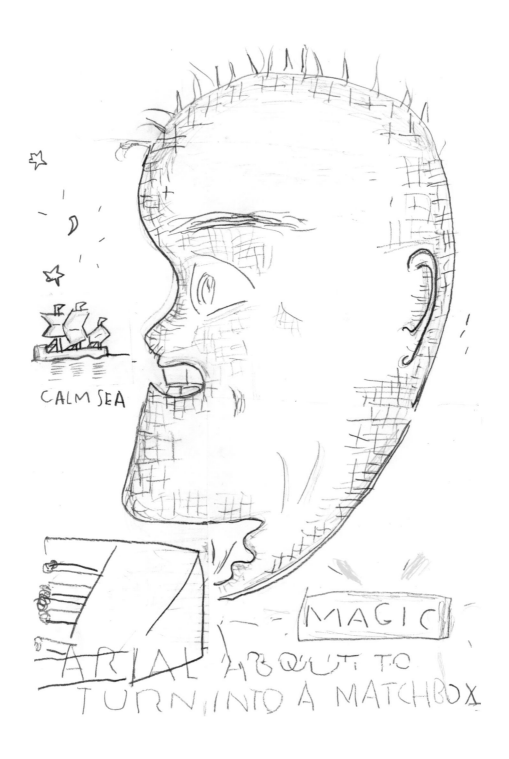

CALM SEA

MAGIC

ARIAL ABOUT TO
TURN INTO A MATCHBOX

PROSPERO Hagseed, hence!
Fetch us in fuel; and be quick, thou 'rt best,* *you better*
430 To answer other business. Shrug'st thou, malice?
If thou neglect'st or dost unwillingly
What I command, I'll rack thee with old* cramps, *(such as old people have)*
Fill all thy bones with aches, make thee roar
That beasts shall tremble at thy din.

435 CALIBAN No, pray thee.
[*Aside*] I must obey. His art is of such pow'r
It would control my dam's god, Setebos,
And make a vassal of him.

PROSPERO So, slave, hence.

[*Caliban exits. Enter Ferdinand; and Ariel, invisible, playing and singing.*]

440 ARIEL Come unto these yellow sands,
 And then take hands.
Curtsied when you have, and kissed
 The wild waves whist.
Foot it featly* here and there, *nimbly*
445 And sweet sprites the burden bear
 Hark, hark!
 [*Burden dispersedly**] Bow-wow. *(An undersong, or refrain)*
 The watchdogs bark.
 [*Burden dispersedly*] Bow-wow.
450 Hark, hark! I hear
The strain of strutting chanticleer
 Cry cock-a-diddle-dow.

FERDINAND Where should this music be? I' th' air, or th' earth?
It sounds no more; and sure it waits upon
455 Some god o' th' island. Sitting on a bank,
Weeping again the King my father's wrack,
This music crept by me upon the waters,
Allaying both their fury and my passion* *grief*
With its sweet air. Thence I have followed it,

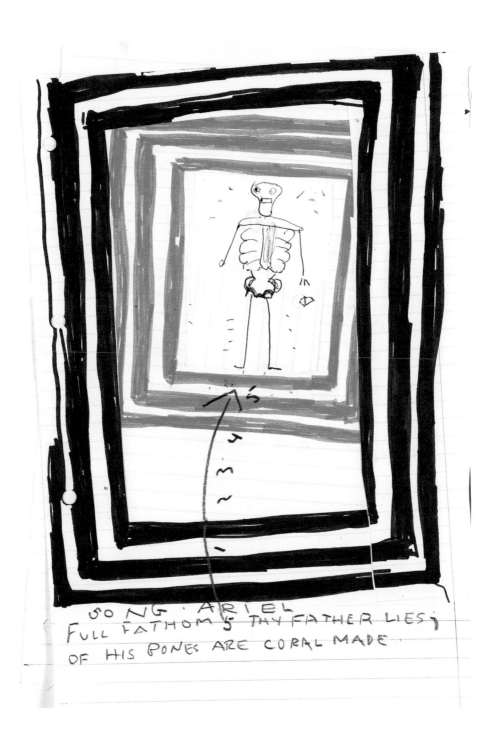

460 Or it hath drawn me rather. But 'tis gone.
No, it begins again.

ARIEL Full fathom five thy father lies.
 Of his bones are coral made.
Those are pearls that were his eyes.
465 Nothing of him that doth fade
But doth suffer a sea change
Into something rich and strange.
Sea nymphs hourly ring his knell.
[*Burden*] Ding dong.
470 Hark, now I hear them: ding dong bell.

FERDINAND The ditty does remember my drowned father.
This is no mortal business, nor no sound
That the Earth owes.* I hear it now above me. *owns*

PROSPERO The fringèd curtains of thine eye advance* *raise*
475 And say what thou seest yond.

MIRANDA What is 't? A spirit?
Lord, how it looks about! Believe me, sir,
It carries a brave form. But 'tis a spirit.

PROSPERO No, wench, it eats and sleeps and hath such senses
480 As we have, such. This gallant which thou seest
Was in the wrack; and, but he's something stained
With grief (that's beauty's canker), thou might'st call him
A goodly person. He hath lost his fellows
And strays about to find 'em.

485 MIRANDA I might call him
A thing divine, for nothing natural
I ever saw so noble.

PROSPERO [*Aside*] It goes on, I see,
As my soul prompts it. [*To Ariel*] Spirit, fine spirit, I'll free thee
490 Within two days for this.

FERDINAND [*Seeing Miranda*] Most sure, the goddess
On whom these airs attend! Vouchsafe my prayer
May know if you remain* upon this island, *dwell*
And that you will some good instruction give
495 How I may bear me* here. My prime request, *conduct myself*
Which I do last pronounce, is (O you wonder!)
If you be maid or no.

MIRANDA No wonder, sir,
But certainly a maid.

500 FERDINAND My language? Heavens!
I am the best of them that speak this speech,
Were I but where 'tis spoken.

PROSPERO How? The best?
What wert thou if the King of Naples heard thee?

505 FERDINAND A single* thing, as I am now, that wonders *solitary*
To hear thee speak of Naples. He does hear me,
And that he does I weep. Myself am Naples,
Who with mine eyes, never since at ebb, beheld
The King my father wracked.

510 MIRANDA Alack, for mercy!

FERDINAND Yes, faith, and all his lords, the Duke of Milan
And his brave son being twain.* *two*

PROSPERO [*Aside*] The Duke of Milan
And his more braver daughter could control* thee, *refute*
515 If now 'twere fit to do 't. At the first sight
They have changed eyes.* Delicate Ariel, *fallen in love*
I'll set thee free for this. [*To Ferdinand*] A word, good sir.
I fear you have done yourself some wrong.* A word. *told a lie*

MIRANDA Why speaks my father so ungently? This
520 Is the third man that e'er I saw, the first
That e'er I sighed for. Pity move my father
To be inclined my way!

PRINCE OF NAPLES

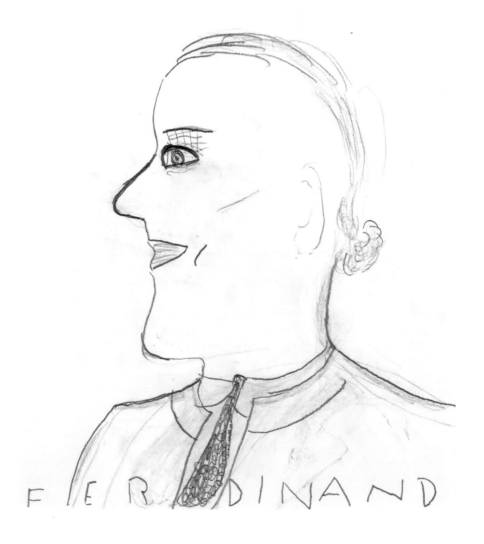

FERDINAND

Ferdinand

FERDINAND O, if a virgin,
And your affection not gone forth, I'll make you
525 The Queen of Naples.

PROSPERO Soft, sir! One word more.
[*Aside*] They are both in either's pow'rs. But this swift business
I must uneasy make, lest too light winning
Make the prize light. [*To Ferdinand*] One word more! I charge thee
530 That thou attend me. Thou dost here usurp
The name thou ow'st* not, and hast put thyself *ownest*
Upon this island as a spy, to win it
From me, the lord on 't.

FERDINAND No, as I am a man!

535 MIRANDA There's nothing ill can dwell in such a temple.
If the ill spirit have so fair a house,
Good things will strive to dwell with 't.

PROSPERO [*To Ferdinand*] Follow me.
[*To Miranda*] Speak not you for him. He's a traitor.
540 [*To Ferdinand*] Come!
I'll manacle thy neck and feet together.
Sea water shalt thou drink. Thy food shall be
The fresh-brook mussels, withered roots, and husks
Wherein the acorn cradled. Follow!

545 FERDINAND No.
I will resist such entertainment till
Mine enemy has more pow'r.
[*He draws, and is charmed from moving.*]

MIRANDA O dear father,
Make not too rash a trial of him, for
550 He's gentle* and not fearful. *of noble birth*

PROSPERO What, I say,
My foot my tutor?* [*To Ferdinand*] Put thy sword up, traitor, *Instructed by my inferior*

Who mak'st a show, but dar'st not strike, thy conscience
Is so possessed with guilt! Come from thy ward,* *fighting stance*
555 For I can here disarm thee with this stick* *wand*
And make thy weapon drop.

MIRANDA Beseech you, father—

PROSPERO Hence! Hang not on my garments.

MIRANDA Sir, have pity.
560 I'll be his surety.

PROSPERO Silence! One word more
Shall make me chide thee, if not hate thee. What,
An advocate for an impostor? Hush!
Thou think'st there is no more such shapes as he,
565 Having seen but him and Caliban. Foolish wench!
To th' most of men this is a Caliban,
And they to him are angels.

MIRANDA My affections
Are then most humble. I have no ambition
570 To see a goodlier man.

PROSPERO [*To Ferdinand*] Come on, obey.
Thy nerves* are in their infancy again *sinews*
And have no vigor in them.

FERDINAND So they are.
575 My spirits, as in a dream, are all bound up.
My father's loss, the weakness which I feel,
The wrack of all my friends, nor this man's threats
To whom I am subdued, are but light to me,
Might I but through my prison once a day
580 Behold this maid. All corners else o' th' Earth
Let liberty make use of. Space enough
Have I in such a prison.

PROSPERO [*Aside*] It works. [*To Ferdinand*] Come on.
[*To Ariel*] Thou hast done well, fine Ariel. [*To Ferdinand*] Follow me.
585 [*To Ariel*] Hark what thou else shalt do me.

MIRANDA Be of comfort.
My father's of a better nature, sir,
Than he appears by speech. This is unwonted
Which now came from him.

590 PROSPERO [*To Ariel*] Thou shalt be as free
As mountain winds; but then* exactly do *till then*
All points of my command.

ARIEL To th' syllable.

PROSPERO [*To Ferdinand*] Come follow.
595 [*To Miranda*] Speak not for him.

[*They exit.*]

Act 2.

Scene 1.
Another part of the island

[Enter Alonso, Sebastian, Antonio, Gonzalo, Adrian, Francisco, and others.]

GONZALO Beseech you, sir, be merry. You have cause
(So have we all) of joy, for our escape
Is much beyond our loss. Our hint of* woe *occasion for*
Is common; every day some sailor's wife,
5 The masters of some merchant,* and the merchant *merchant ship*
Have just our theme of woe. But for the miracle,
I mean our preservation, few in millions
Can speak like us. Then wisely, good sir, weigh
Our sorrow with* our comfort. *against*

10 ALONSO Prithee, peace.

SEBASTIAN *[Aside to Antonio]* He* receives comfort like cold porridge. *(Alonso)*

ANTONIO The visitor* will not give him o'er* so. *spiritual adviser | release him*

SEBASTIAN Look, he's winding up the watch of his wit. By and by
it will strike.

15 GONZALO *[To Alonso]* Sir—

SEBASTIAN *[Aside to Antonio]* One. Tell.* *(Keep count)*

GONZALO When every grief is entertained that's offered,
Comes to th' entertainer—

SEBASTIAN A dollar.

20 GONZALO Dolor comes to him indeed. You have spoken truer than
you purposed.

SEBASTIAN You have taken it wiselier* than I meant you should. *understood the pun

GONZALO Therefore, my lord—

ANTONIO Fie, what a spendthrift is he of his tongue.

25 ALONSO I prithee, spare.* *spare your words

GONZALO Well, I have done. But yet—

SEBASTIAN He will be talking.

ANTONIO Which, of he or Adrian, for a good wager, first begins
to crow?

30 SEBASTIAN The old cock.* *(Gonzalo)

ANTONIO The cock'rel.* *(Adrian)

SEBASTIAN Done. The wager?

ANTONIO A laughter.* *(The winner laughs)

SEBASTIAN A match!

35 ADRIAN Though this island seem to be desert—

ANTONIO Ha, ha, ha.

SEBASTIAN So. You're paid.

ADRIAN Uninhabitable and almost inaccessible—

SEBASTIAN Yet—

40 ADRIAN Yet—

ANTONIO He could not miss 't.

ADRIAN It must needs be of subtle, tender, and delicate temperance.* *climate*

ANTONIO Temperance was a delicate wench.

SEBASTIAN Ay, and a subtle, as he most learnedly delivered.

45 ADRIAN The air breathes upon us here most sweetly.

SEBASTIAN As if it had lungs, and rotten ones.

ANTONIO Or as 'twere perfumed by a fen.

GONZALO Here is everything advantageous to life.

ANTONIO True, save means to live.

50 SEBASTIAN Of that there's none, or little.

GONZALO How lush and lusty the grass looks! How green!

ANTONIO The ground indeed is tawny.

SEBASTIAN With an eye* of green in 't. *spot*

ANTONIO He misses not much.

55 SEBASTIAN No, he doth but mistake the truth totally.

GONZALO But the rarity of it is, which is indeed almost beyond credit—

SEBASTIAN As many vouched rarities are.

GONZALO That our garments, being, as they were, drenched in the sea, hold notwithstanding their freshness and gloss, being rather
60 new-dyed than stained with salt water.

ANTONIO If but one of his pockets could speak, would it not say he lies?

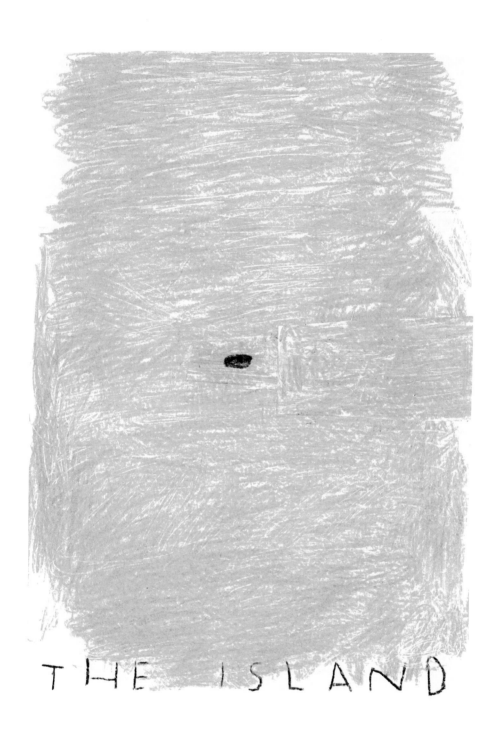

THE ISLAND

The Island, Green

SEBASTIAN Ay, or very falsely pocket up his report.

GONZALO Methinks our garments are now as fresh as when we put
65 them on first in Afric, at the marriage of the King's fair daughter
Claribel to the King of Tunis.

SEBASTIAN 'Twas a sweet marriage, and we prosper well in
our return.

ADRIAN Tunis was never graced before with such a paragon to* *for*
70 their queen.

GONZALO Not since widow Dido's time.

ANTONIO Widow? A pox o' that! How came that "widow" in?
Widow Dido!

SEBASTIAN What if he had said "widower Aeneas" too? Good Lord,
75 how you take it!

ADRIAN "Widow Dido," said you? You make me study of that.
She was of Carthage, not of Tunis.

GONZALO This Tunis, sir, was Carthage.

ADRIAN Carthage?

80 GONZALO I assure you, Carthage.

ANTONIO His word is more than the miraculous harp.

SEBASTIAN He hath raised the wall, and houses too.

ANTONIO What impossible matter will he make easy next?

SEBASTIAN I think he will carry this island home in his pocket and
85 give it his son for an apple.

ANTONIO And sowing the kernels of it in the sea, bring forth more islands.

GONZALO Ay.

ANTONIO Why, in good time.

90 GONZALO [*To Alonso*] Sir, we were talking that our garments seem now as fresh as when we were at Tunis at the marriage of your daughter, who is now queen.

ANTONIO And the rarest that e'er came there.

SEBASTIAN Bate,* I beseech you, widow Dido. *Except*

95 ANTONIO O, widow Dido? Ay, widow Dido.

GONZALO Is not, sir, my doublet as fresh as the first day I wore it? I mean, in a sort.* *so to speak*

ANTONIO That "sort" was well fished for.

GONZALO When I wore it at your daughter's marriage.

100 ALONSO You cram these words into mine ears against
 The stomach of my sense.* Would I had never *(no appetite for them)*
 Married my daughter there, for coming thence
 My son is lost, and, in my rate,* she too, *opinion*
 Who is so far from Italy removed
105 I ne'er again shall see her. O, thou mine heir
 Of Naples and of Milan, what strange fish
 Hath made his meal on thee?

 FRANCISCO Sir, he may live.
 I saw him beat the surges under him
110 And ride upon their backs. He trod the water,
 Whose enmity he flung aside, and breasted
 The surge most swol'n that met him. His bold head

'Bove the contentious waves he kept, and oared
Himself with his good arms in lusty stroke
115 To th' shore, that o'er his* wave-worn basis bowed, *its*
As stooping to relieve him. I not doubt
He came alive to land.

ALONSO No, no, he's gone.

SEBASTIAN Sir, you may thank yourself for this great loss,
120 That would not bless our Europe with your daughter,
But rather lose her to an African,
Where she at least is banished from your eye,
Who hath cause to wet the grief on 't.

ALONSO Prithee, peace.

125 SEBASTIAN You were kneeled to and importuned otherwise
By all of us; and the fair soul herself
Weighed between loathness and obedience at
Which end o' th' beam should bow. We have lost your son,
I fear, forever. Milan and Naples have
130 Moe* widows in them of this business' making *More*
Than we bring men to comfort them.
The fault's your own.

ALONSO So is the dear'st o' th' loss.

GONZALO My lord Sebastian,
135 The truth you speak doth lack some gentleness
And time to speak it in. You rub the sore
When you should bring the plaster.

SEBASTIAN Very well.

ANTONIO And most chirurgeonly.* *like a surgeon*

140 GONZALO [*To Alonso*] It is foul weather in us all, good sir,
When you are cloudy.

SEBASTIAN Foul weather?

ANTONIO Very foul.

GONZALO Had I plantation* of this isle, my lord— *colonization*

145 ANTONIO He'd sow 't with nettle seed.

SEBASTIAN Or docks, or mallows.

GONZALO And were the king on 't, what would I do?

SEBASTIAN Scape being drunk, for want of wine.

GONZALO I' th' commonwealth I would by contraries* *in contrast to usual customs*
150 Execute all things, for no kind of traffic* *trade*
Would I admit; no name of magistrate;
Letters* should not be known; riches, poverty, *Learning*
And use of service,* none; contract, succession,* *servants / inheritance*
Bourn,* bound of land, tilth,* vineyard, none; *Boundaries of property / agriculture*
155 No use of metal, corn, or wine, or oil;
No occupation; all men idle, all,
And women too, but innocent and pure;
No sovereignty.

SEBASTIAN Yet he would be king on 't.

160 ANTONIO The latter end of his commonwealth forgets
the beginning.

GONZALO All things in common nature should produce
Without sweat or endeavor; treason, felony,
Sword, pike, knife, gun, or need of any engine* *weapon*
165 Would I not have; but nature should bring forth
Of it* own kind all foison,* all abundance, *its / abundance*
To feed my innocent people.

SEBASTIAN No marrying 'mong his subjects?

ANTONIO None, man, all idle: whores and knaves.

170 GONZALO I would with such perfection govern, sir,
T' excel the Golden Age.

SEBASTIAN Save his Majesty!

ANTONIO Long live Gonzalo!

GONZALO And do you mark me, sir?

175 ALONSO Prithee, no more. Thou dost talk nothing to me.

GONZALO I do well believe your Highness, and did it to minister
occasion* to these gentlemen, who are of such sensible* and *afford opportunity | sensitive*
nimble lungs that they always use to laugh at nothing.

ANTONIO 'Twas you we laughed at.

180 GONZALO Who in this kind of merry fooling am nothing to you.
So you may continue, and laugh at nothing still.

ANTONIO What a blow was there given!

SEBASTIAN And* it had not fall'n flatlong.* *If | with the flat of a sword*

GONZALO You are gentlemen of brave mettle. You would lift
185 the moon out of her sphere if she would continue in it five weeks
without changing.

[*Enter Ariel, invisible, playing solemn music.*]

SEBASTIAN We would so, and then go a-batfowling.* *hunting for birds at night*

ANTONIO Nay, good my lord, be not angry.

GONZALO No, I warrant you, I will not adventure my discretion so
190 weakly. Will you laugh me asleep? For I am very heavy.

ANTONIO Go sleep, and hear us.

[*All sleep except Alonso, Antonio, and Sebastian.*]

ALONSO What, all so soon asleep? I wish mine eyes
Would, with themselves, shut up my thoughts. I find
They are inclined to do so.

195 SEBASTIAN Please you, sir,
Do not omit* the heavy offer of it. *neglect*
It seldom visits sorrow; when it doth,
It is a comforter.

ANTONIO We two, my lord,
200 Will guard your person while you take your rest,
And watch your safety.

ALONSO Thank you. Wondrous heavy.

[*Alonso sleeps. Ariel exits.*]

SEBASTIAN What a strange drowsiness possesses them!

ANTONIO It is the quality o' th' climate.

205 SEBASTIAN Why
Doth it not then our eyelids sink? I find not
Myself disposed to sleep.

ANTONIO Nor I. My spirits are nimble.
They fell together all, as by consent.
210 They dropped as by a thunderstroke. What might,
Worthy Sebastian—O, what might?—No more!
And yet methinks I see it in thy face
What thou shouldst be. Th' occasion speaks thee, and
My strong imagination sees a crown
215 Dropping upon thy head.

SEBASTIAN What, art thou waking?

ANTONIO Do you not hear me speak?

SEBASTIAN I do, and surely
It is a sleepy language, and thou speak'st
220 Out of thy sleep. What is it thou didst say?
This is a strange repose, to be asleep
With eyes wide open—standing, speaking, moving—
And yet so fast asleep.

ANTONIO Noble Sebastian,
225 Thou let'st thy fortune sleep, die rather, wink'st* *dost sleep*
Whiles thou art waking.

SEBASTIAN Thou dost snore distinctly.
There's meaning in thy snores.

ANTONIO I am more serious than my custom. You
230 Must be so too, if heed me; which to do
Trebles thee o'er.* *makes status threefold*

SEBASTIAN Well, I am standing water.

ANTONIO I'll teach you how to flow.

SEBASTIAN Do so. To ebb
235 Hereditary sloth instructs me.

ANTONIO O,
If you but knew how you the purpose cherish
Whiles thus you mock it, how in stripping it
You more invest it. Ebbing men indeed
240 Most often do so near the bottom run
By their own fear or sloth.

SEBASTIAN Prithee, say on.
The setting of thine eye and cheek proclaim
A matter* from thee, and a birth indeed *matter of importance*
245 Which throes thee much* to yield. *causes much pain*

ANTONIO Thus, sir:
Although this lord of weak remembrance,* this *memory*
Who shall be of as little memory* *little remembered*
When he is earthed,* hath here almost persuaded *buried*
250 (For he's a spirit of persuasion, only
Professes to* persuade) the King his son's alive, *Profession is to*
'Tis as impossible that he's undrowned
As he that sleeps here swims.

SEBASTIAN I have no hope
255 That he's undrowned.

ANTONIO O, out of that no hope
What great hope have you! No hope that way is
Another way so high a hope that even
Ambition cannot pierce a wink beyond,
260 But doubt discovery there. Will you grant with me
That Ferdinand is drowned?

SEBASTIAN He's gone.

ANTONIO Then tell me,
Who's the next heir of Naples?

265 SEBASTIAN Claribel.

ANTONIO She that is Queen of Tunis; she that dwells
Ten leagues beyond man's life;* she that from Naples *(thirty miles from nowhere)*
Can have no note, unless the sun were post*— *messenger*
The man i' th' moon's too slow—till newborn chins
270 Be rough and razorable;* she that from whom *ready to shave*
We all were sea-swallowed, though some cast again,
And by that destiny to perform an act
Whereof what's past is prologue, what to come
In yours and my discharge.

275 SEBASTIAN What stuff is this? How say you?
'Tis true my brother's daughter's Queen of Tunis,

So is she heir of Naples, 'twixt which regions
There is some space.

ANTONIO A space whose ev'ry cubit
280 Seems to cry out "How shall that Claribel
Measure us back to Naples? Keep in Tunis
And let Sebastian wake." Say this were death
That now hath seized them, why, they were no worse
Than now they are. There be that can rule Naples
285 As well as he that sleeps, lords that can prate
As amply and unnecessarily
As this Gonzalo. I myself could make
A chough* of as deep chat. O, that you bore *jackdaw (bird)*
The mind that I do! What a sleep were this
290 For your advancement! Do you understand me?

SEBASTIAN Methinks I do.

ANTONIO And how does your content
Tender* your own good fortune? *Regard*

SEBASTIAN I remember
295 You did supplant your brother Prospero.

ANTONIO True,
And look how well my garments sit upon me,
Much feater* than before. My brother's servants *more becomingly*
Were then my fellows; now they are my men.

300 SEBASTIAN But, for your conscience?

ANTONIO Ay, sir, where lies that? If 'twere a kibe,* *chilblain*
'Twould put me to my slipper, but I feel not
This deity in my bosom. Twenty consciences
That stand 'twixt me and Milan, candied be they
305 And melt ere they molest! Here lies your brother,
No better than the earth he lies upon.
If he were that which now he's like—that's dead—

Whom I with this obedient steel, three inches of it,
Can lay to bed forever; whiles you, doing thus,
310 To the perpetual wink* for aye might put *sleep*
This ancient morsel, this Sir Prudence, who
Should not upbraid our course. For all the rest,
They'll take suggestion as a cat laps milk.
They'll tell the clock* to any business that *say yes*
315 We say befits the hour.

SEBASTIAN Thy case, dear friend,
Shall be my precedent: as thou got'st Milan,
I'll come by Naples. Draw thy sword. One stroke
Shall free thee from the tribute which thou payest,
320 And I the King shall love thee.

ANTONIO Draw together,
And when I rear my hand, do you the like
To fall it on Gonzalo. [*They draw their swords.*]

SEBASTIAN O, but one word!

[*Enter Ariel, invisible, with music and song.*]

325 ARIEL My master through his art foresees the danger
That you, his friend, are in, and sends me forth
(For else his project dies) to keep them living.
[*Sings in Gonzalo's ear*]
While you here do snoring lie,
Open-eyed conspiracy
330 His time doth take.
If of life you keep a care,
Shake off slumber and beware.
 Awake, awake!

ANTONIO Then let us both be sudden.

335 GONZALO [*Waking*] Now, good angels
Preserve the King!

[*The others wake.*]

ALONSO Why, how now. Ho, awake! Why are you drawn?
Wherefore this ghastly looking?

GONZALO What's the matter?

340 SEBASTIAN Whiles we stood here securing your repose,
Even now, we heard a hollow burst of bellowing
Like bulls, or rather lions. Did 't not wake you?
It struck mine ear most terribly.

ALONSO I heard nothing.

345 ANTONIO O, 'twas a din to fright a monster's ear,
To make an earthquake. Sure, it was the roar
Of a whole herd of lions.

ALONSO Heard you this, Gonzalo?

GONZALO Upon mine honor, sir, I heard a humming,
350 And that a strange one too, which did awake me.
I shaked you, sir, and cried. As mine eyes opened,
I saw their weapons drawn. There was a noise,
That's verily.* 'Tis best we stand upon our guard, *the truth*
Or that we quit this place. Let's draw our weapons.

355 ALONSO Lead off this ground, and let's make further search
For my poor son.

GONZALO Heavens keep him from these beasts,
For he is, sure, i' th' island.

ALONSO Lead away.

360 ARIEL Prospero my lord shall know what I have done.
So, king, go safely on to seek thy son.

[*They exit.*]

Scene 2.
Another part of the island

[*Enter Caliban with a burden of wood. A noise of thunder heard.*]

CALIBAN All the infections that the sun sucks up
From bogs, fens, flats, on Prosper fall, and make him
By inchmeal* a disease! His spirits hear me, *inch by inch*
And yet I needs must curse. But they'll nor pinch,
5 Fright me with urchin-shows,* pitch me i' th' mire, *impish apparitions*
Nor lead me like a firebrand* in the dark *in the form of a will-o'-the-wisp*
Out of my way, unless he bid 'em. But
For every trifle are they set upon me,
Sometime like apes, that mow* and chatter at me *make faces*
10 And after bite me; then like hedgehogs which
Lie tumbling in my barefoot way and mount
Their pricks at my footfall. Sometime am I
All wound with adders, who with cloven tongues
Do hiss me into madness. [*Enter Trinculo.*]
15 Lo, now, lo!
Here comes a spirit of his, and to torment me
For bringing wood in slowly. I'll fall flat.
Perchance he will not mind me. [*He lies down.*]

TRINCULO Here's neither bush nor shrub to bear* off any weather *ward*
20 at all. And another storm brewing; I hear it sing i' th' wind. Yond
same black cloud, yond huge one, looks like a foul bombard* that *leather bottle*
would shed his liquor. If it should thunder as it did before, I know not
where to hide my head. Yond same cloud cannot choose but fall by
pailfuls. What have we here, a man or a fish? Dead or alive? A fish,
25 he smells like a fish—a very ancient and fishlike smell, a kind of
not-of-the-newest poor-John.* A strange fish. Were I in England now, *dried hake*
as once I was, and had but this fish painted,* not a holiday fool there *as a signboard*
but would give a piece of silver. There would this monster make

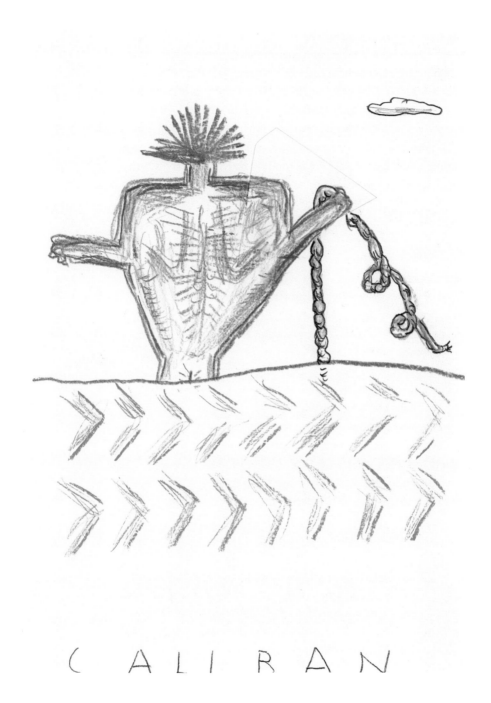

CALIBAN

a man. Any strange beast there makes a man. When they will not give
a doit* to relieve a lame beggar, they will lay out ten to see a dead *small coin*
Indian. Legged like a man, and his fins like arms! Warm, o' my troth!
I do now let loose my opinion, hold it no longer: this is no fish, but
an islander that hath lately suffered by a thunderbolt. [*Thunder.*] Alas,
the storm is come again. My best way is to creep under his gaberdine.
There is no other shelter hereabout. Misery acquaints a man with
strange bedfellows. I will here shroud till the dregs of the storm be
past. [*He crawls under Caliban's cloak.*]

[*Enter Stephano, singing.*]

STEPHANO I shall no more to sea, to sea.
Here shall I die ashore.
This is a very scurvy tune to sing at a man's funeral.
Well, here's my comfort. [*Drinks.*]
The master, the swabber, the boatswain, and I,
 The gunner and his mate,
Loved Mall, Meg, and Marian, and Margery,
 But none of us cared for Kate.
 For she had a tongue with a tang,
 Would cry to a sailor "Go hang!"
She loved not the savor of tar nor of pitch,
Yet a tailor might scratch her where'er she did itch.
 Then to sea, boys, and let her go hang!
This is a scurvy tune too. But here's my comfort. [*Drinks.*]

CALIBAN Do not torment me! O!

STEPHANO What's the matter? Have we devils here? Do you put tricks
upon 's with savages and men of Inde, ha! I have not scaped drowning
to be afeard now of your four legs, for it hath been said, "As proper
a man as ever went on four legs cannot make him give ground," and
it shall be said so again while Stephano breathes at'* nostrils. *at the*

CALIBAN The spirit torments me. O!

Line numbers: 30, 35, 40, 45, 50, 55

STEPHANO This is some monster of the isle, with four legs, who hath
60 got, as I take it, an ague. Where the devil should he learn our language?
 I will give him some relief, if it be but for that. If I can recover* him *cure*
 and keep him tame and get to Naples with him, he's a present for any
 emperor that ever trod on neat's leather.* *cowhide*

CALIBAN Do not torment me, prithee. I'll bring my wood home faster.

65 STEPHANO He's in his fit now, and does not talk after the wisest. He
 shall taste of my bottle. If he have never drunk wine afore, it will go
 near to remove his fit. If I can recover him and keep him tame, I will
 not take too much* for him. He shall pay for him that hath him, and *take all I can get*
 that soundly.

70 CALIBAN Thou dost me yet but little hurt. Thou wilt anon;* I know it *soon*
 by thy trembling. Now Prosper works upon thee.

STEPHANO Come on your ways. Open your mouth. Here is that which
 will give language to you, cat. Open your mouth. This will shake your
 shaking, I can tell you, and that soundly. [*Caliban drinks.*] You cannot
75 tell who's your friend. Open your chaps* again. *jaws*

TRINCULO I should know that voice. It should be—but he is drowned,
 and these are devils. O, defend me!

STEPHANO Four legs and two voices—a most delicate monster! His
 forward voice now is to speak well of his friend. His backward voice is
80 to utter foul speeches and to detract. If all the wine in my bottle will
 recover him, I will help his ague. Come. [*Caliban drinks.*] Amen! I will
 pour some in thy other mouth.

TRINCULO Stephano!

STEPHANO Doth thy other mouth call me? Mercy, mercy, this is
85 a devil, and no monster! I will leave him; I have no long spoon.

TRINCULO Stephano! If thou be'st Stephano, touch me and speak to
 me, for I am Trinculo—be not afeard—thy good friend Trinculo.

STEPHANO If thou be'st Trinculo, come forth. I'll pull thee by the
lesser legs. If any be Trinculo's legs, these are they. [*He pulls him out*
from under Caliban's cloak.] Thou art very Trinculo indeed. How cam'st
thou to be the siege* of this mooncalf?* Can he vent Trinculos? *excrement | monstrosity*

TRINCULO I took him to be killed with a thunderstroke. But art
thou not drowned, Stephano? I hope now thou art not drowned. Is
the storm overblown? I hid me under the dead mooncalf's gaberdine
for fear of the storm. And art thou living, Stephano? O Stephano,
two Neapolitans scaped!

STEPHANO Prithee, do not turn me about. My stomach is not constant.

CALIBAN [*Aside*] These be fine things, an if they be not sprites.
That's a brave god and bears celestial liquor.
I will kneel to him. [*He crawls out from under the cloak.*]

STEPHANO How didst thou scape? How cam'st thou hither? Swear
by this bottle how thou cam'st hither—I escaped upon a butt of sack,
which the sailors heaved o'erboard—by this bottle, which I made of
the bark of a tree with mine own hands, since I was cast ashore.

CALIBAN I'll swear upon that bottle to be thy true subject, for the
liquor is not earthly.

STEPHANO Here! Swear then how thou escap'dst.

TRINCULO Swum ashore, man, like a duck. I can swim like a duck,
I'll be sworn.

STEPHANO Here, kiss the book. [*Trinculo drinks.*]
Though thou canst swim like a duck, thou art made like a goose.

TRINCULO O Stephano, hast any more of this?

STEPHANO The whole butt, man. My cellar is in a rock by th' seaside,
where my wine is hid. How now, mooncalf, how does thine ague?

115 CALIBAN Hast thou not dropped from heaven?

STEPHANO Out o' th' moon, I do assure thee. I was the man i' th' moon when time was.* *once upon a time*

CALIBAN I have seen thee in her, and I do adore thee.
My mistress showed me thee, and thy dog, and thy bush.

120 STEPHANO Come, swear to that. Kiss the book. I will furnish it anon with new contents. Swear. [*Caliban drinks.*]

TRINCULO By this good light, this is a very shallow monster. I afeard of him? A very weak monster. The man i' th' moon? A most poor, credulous monster! Well drawn,* monster, in good sooth! *A good draw from the bottle*

125 CALIBAN I'll show thee every fertile inch o' th' island, and I will kiss thy foot. I prithee, be my god.

TRINCULO By this light, a most perfidious and drunken monster.
When 's god's asleep, he'll rob his bottle.

CALIBAN I'll kiss thy foot. I'll swear myself thy subject.

130 STEPHANO Come on, then. Down, and swear.

TRINCULO I shall laugh myself to death at this puppy-headed monster.
A most scurvy monster. I could find in my heart to beat him—

STEPHANO Come, kiss.

TRINCULO But that the poor monster's in drink. An abominable
135 monster.

CALIBAN I'll show thee the best springs. I'll pluck thee berries.
I'll fish for thee and get thee wood enough.
A plague upon the tyrant that I serve.
I'll bear him no more sticks, but follow thee,
140 Thou wondrous man.

TRINCULO A most ridiculous monster, to make a wonder of a poor
drunkard.

CALIBAN I prithee, let me bring thee where crabs* grow, *crab apples*
And I with my long nails will dig thee pignuts,* *earth nuts*
145 Show thee a jay's nest, and instruct thee how
To snare the nimble marmoset. I'll bring thee
To clust'ring filberts, and sometimes I'll get thee
Young scamels from the rock. Wilt thou go with me?

STEPHANO I prithee now, lead the way without any more talking.
150 Trinculo, the King and all our company else being drowned, we will
inherit* here. Here, bear my bottle. Fellow Trinculo, we'll fill him by *take possession*
and by again.

CALIBAN [*Sings drunkenly*] Farewell, master, farewell, farewell.

TRINCULO A howling monster, a drunken monster.

155 CALIBAN [*Sings*] No more dams I'll make for fish,
 Nor fetch in firing
 At requiring,
Nor scrape trenchering,* nor wash dish. *wooden dishes*
 'Ban, 'ban, Ca-caliban
160 Has a new master. Get a new man.
Freedom, high-day! High-day, freedom! Freedom, high-day, freedom!

STEPHANO O brave monster! Lead the way.

[*They exit.*]

Act 3.

Scene 1.
In front of Prospero's cell

[Enter Ferdinand bearing a log.]

FERDINAND There be some sports are painful, and their labor
Delight in them sets off;* some kinds of baseness *cancels*
Are nobly undergone, and most poor matters
Point to rich ends. This my mean task
5 Would be as heavy to me as odious, but
The mistress which I serve quickens* what's dead *brings to life*
And makes my labors pleasures. O, she is
Ten times more gentle than her father's crabbed,
And he's composed of harshness. I must remove
10 Some thousands of these logs and pile them up,
Upon a sore injunction.* My sweet mistress *severe command*
Weeps when she sees me work, and says such baseness
Had never like executor. I forget;* *(forget my task)*
But these sweet thoughts do even refresh my labors,
15 Most busiest when I do it.

[Enter Miranda; and Prospero at a distance, unobserved.]

MIRANDA Alas now, pray you,
Work not so hard. I would the lightning had
Burnt up those logs that you are enjoined to pile.
Pray, set it down and rest you. When this burns
20 'Twill weep* for having wearied you. My father *exude resin*
Is hard at study. Pray now, rest yourself.
He's safe for these three hours.

FERDINAND O most dear mistress,
The sun will set before I shall discharge
25 What I must strive to do.

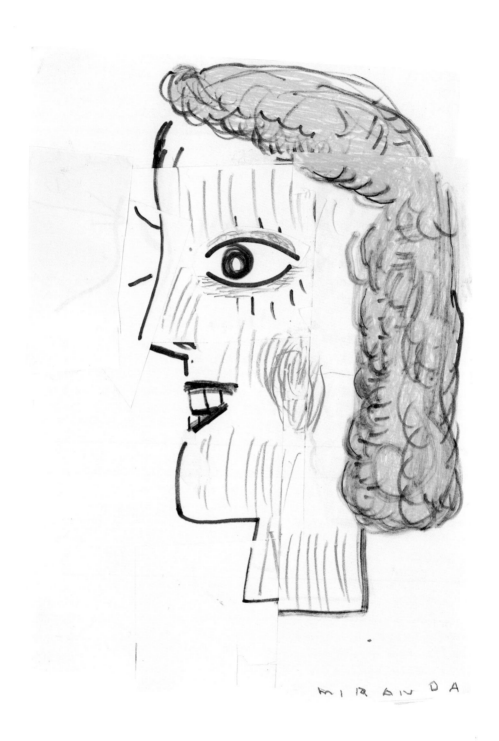

MIRANDA

Miranda

MIRANDA If you'll sit down,
I'll bear your logs the while. Pray, give me that.
I'll carry it to the pile.

FERDINAND No, precious creature,
30 I had rather crack my sinews, break my back,
Than you should such dishonor undergo
While I sit lazy by.

MIRANDA It would become me
As well as it does you, and I should do it
35 With much more ease, for my good will is to it,
And yours it is against.

PROSPERO [*Aside*] Poor worm, thou art infected.
This visitation shows it.

MIRANDA You look wearily.

40 FERDINAND No, noble mistress, 'tis fresh morning with me
When you are by at night.* I do beseech you, *even at night*
Chiefly that I might set it in my prayers,
What is your name?

MIRANDA Miranda. O my father,
45 I have broke your hest* to say so! *command*

FERDINAND Admired* Miranda! *To be wondered at*
Indeed the top of admiration, worth
What's dearest to the world! Full many a lady
I have eyed with best regard, and many a time
50 Th' harmony of their tongues hath into bondage
Brought my too diligent ear. For several virtues
Have I liked several women, never any
With so full soul but some defect in her
Did quarrel with the noblest grace she owed,* *owned*
55 And put it to the foil. But you, O you,
So perfect and so peerless, are created
Of every creature's best.

79

MIRANDA I do not know
One of my sex, no woman's face remember,
60 Save, from my glass, mine own. Nor have I seen
More that I may call men than you, good friend,
And my dear father. How features are abroad
I am skilless* of, but by my modesty *ignorant*
(The jewel in my dower) I would not wish
65 Any companion in the world but you,
Nor can imagination form a shape
Besides yourself to like of. But I prattle
Something too wildly, and my father's precepts
I therein do forget.

70 FERDINAND I am in my condition
A prince, Miranda; I do think a king
(I would, not so), and would no more endure
This wooden slavery than to suffer
The flesh-fly blow my mouth. Hear my soul speak:
75 The very instant that I saw you did
My heart fly to your service, there resides
To make me slave to it, and for your sake
Am I this patient log-man.

MIRANDA Do you love me?

80 FERDINAND O heaven, O Earth, bear witness to this sound,
And crown what I profess with kind event* *outcome*
If I speak true; if hollowly, invert
What best is boded* me to mischief. I, *fate has in store for*
Beyond all limit of what else i' th' world,
85 Do love, prize, honor you.

MIRANDA I am a fool
To weep at what I am glad of.

PROSPERO [*Aside*] Fair encounter
Of two most rare affections. Heavens rain grace
90 On that which breeds between 'em!

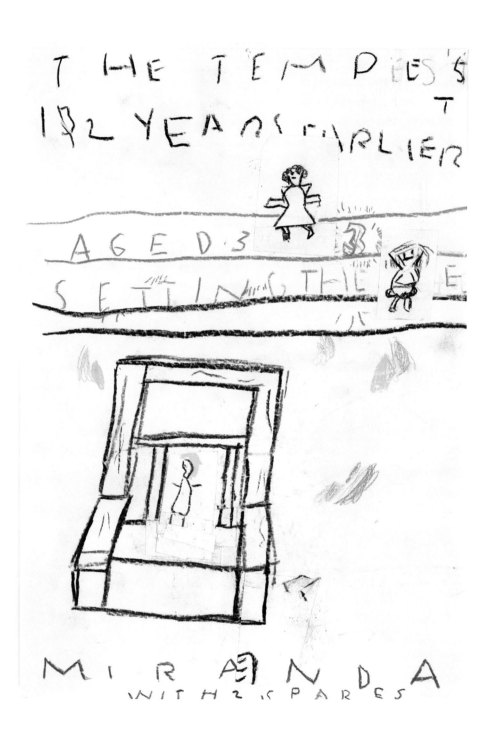

FERDINAND Wherefore weep you?

MIRANDA At mine unworthiness, that dare not offer
What I desire to give, and much less take
What I shall die to want.* But this is trifling, *lack*
95 And all the more it seeks to hide itself,
The bigger bulk it shows. Hence, bashful cunning,
And prompt me, plain and holy innocence.
I am your wife if you will marry me.
If not, I'll die your maid. To be your fellow* *equal*
100 You may deny me, but I'll be your servant
Whether you will or no.

FERDINAND My mistress, dearest,
And I thus humble ever.

MIRANDA My husband, then?

105 FERDINAND Ay, with a heart as willing
As bondage e'er of freedom.* Here's my hand. *to win freedom*

MIRANDA And mine, with my heart in 't. And now farewell
Till half an hour hence.

FERDINAND A thousand thousand!

[*They exit.*]

110 PROSPERO So glad of this as they I cannot be,
Who are surprised withal;* but my rejoicing *by*
At nothing can be more. I'll to my book,
For yet ere suppertime must I perform
Much business appertaining.* *relevant*

[*He exits.*]

Scene 2.
Another part of the island

[*Enter Caliban, Stephano, and Trinculo.*]

STEPHANO Tell not me! When the butt is out, we will drink water;
not a drop before. Therefore bear up and board 'em.* Servant monster, *drink up*
drink to me.

TRINCULO Servant monster? The folly of this island! They say
5 there's but five upon this isle; we are three of them. If th' other two
be brained like us, the state totters.

STEPHANO Drink, servant monster, when I bid thee. Thy eyes are
almost set in thy head.

TRINCULO Where should they be set else? He were a brave monster
10 indeed if they were set in his tail.

STEPHANO My man-monster hath drowned his tongue in sack. For
my part, the sea cannot drown me. I swam, ere I could recover the
shore, five-and-thirty leagues off and on, by this light.—Thou shalt
be my lieutenant, monster, or my standard.* *standard bearer, ensign*

15 TRINCULO Your lieutenant, if you list.* He's no standard. *if it please you*

STEPHANO We'll not run, Monsieur Monster.

TRINCULO Nor go neither. But you'll lie like dogs, and yet say
nothing neither.

STEPHANO Mooncalf, speak once in thy life, if thou beest a good
20 mooncalf.

CALIBAN How does thy Honor? Let me lick thy shoe. I'll not serve
him; he is not valiant.

TRINCULO Thou liest, most ignorant monster. I am in case* to justle *fit condition
a constable. Why, thou deboshed* fish, thou! Was there ever man a *debauched
25 coward that hath drunk so much sack as I today? Wilt thou tell
a monstrous lie, being but half a fish and half a monster?

CALIBAN Lo, how he mocks me! Wilt thou let him, my lord?

TRINCULO "Lord," quoth he? That a monster should be such a natural!* *idiot

CALIBAN Lo, lo again! Bite him to death, I prithee.

30 STEPHANO Trinculo, keep a good tongue in your head. If you prove
a mutineer, the next tree.* The poor monster's my subject, and he *you will be hanged
shall not suffer indignity.

CALIBAN I thank my noble lord. Wilt thou be pleased to harken once
again to the suit I made to thee?

35 STEPHANO Marry, will I. Kneel and repeat it. I will stand, and so
shall Trinculo.

[Enter Ariel, invisible.]

CALIBAN As I told thee before, I am subject to a tyrant,
A sorcerer, that by his cunning hath
Cheated me of the island.

40 ARIEL Thou liest.

CALIBAN Thou liest, thou jesting monkey, thou.
I would my valiant master would destroy thee.
I do not lie.

STEPHANO Trinculo, if you trouble him any more in 's tale, by this
45 hand, I will supplant some of your teeth.

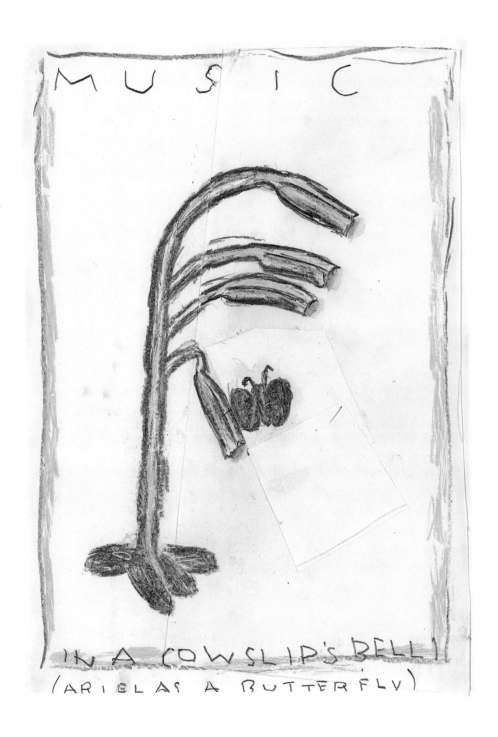

TRINCULO Why, I said nothing.

STEPHANO Mum then, and no more. Proceed.

CALIBAN I say by sorcery he got this isle;
From me he got it. If thy Greatness will
50 Revenge it on him, for I know thou dar'st,
But this thing* dare not. (*Trinculo*)

STEPHANO That's most certain.

CALIBAN Thou shalt be lord of it, and I'll serve thee.

STEPHANO How now shall this be compassed?
55 Canst thou bring me to the party?

CALIBAN Yea, yea, my lord. I'll yield him thee asleep,
Where thou mayst knock a nail into his head.

ARIEL Thou liest. Thou canst not.

CALIBAN What a pied ninny's this! Thou scurvy patch!* *clown*
60 I do beseech thy greatness, give him blows
And take his bottle from him. When that's gone,
He shall drink naught but brine, for I'll not show him
Where the quick freshes* are. *freshwater springs*

STEPHANO Trinculo, run into no further danger. Interrupt the
65 monster one word further, and by this hand, I'll turn my mercy out
o' doors and make a stockfish* of thee. *dried cod*

TRINCULO Why, what did I? I did nothing. I'll go farther off.

STEPHANO Didst thou not say he lied?

ARIEL Thou liest.

70 STEPHANO Do I so? Take thou that. [*He strikes Trinculo.*] As you like
this, give me the lie another time.

86

TRINCULO I did not give the lie! Out o' your wits and hearing too?
A pox o' your bottle! This can sack and drinking do. A murrain* *plague (among cattle)
on your monster, and the devil take your fingers!

75 CALIBAN Ha, ha, ha!

STEPHANO Now forward with your tale.
[*To Trinculo*] Prithee, stand further off.

CALIBAN Beat him enough. After a little time
I'll beat him too.

80 STEPHANO Stand farther. Come, proceed.

CALIBAN Why, as I told thee, 'tis a custom with him
I' th' afternoon to sleep. There thou mayst brain him,
Having first seized his books, or with a log
Batter his skull, or paunch* him with a stake, *stab in the belly
85 Or cut his wezand* with thy knife. Remember *windpipe
First to possess his books, for without them
He's but a sot,* as I am, nor hath not *fool
One spirit to command. They all do hate him
As rootedly as I. Burn but his books.
90 He has brave utensils* (for so he calls them) *fine furnishings
Which, when he has a house, he'll deck withal.
And that most deeply to consider is
The beauty of his daughter. He himself
Calls her a nonpareil. I never saw a woman
95 But only Sycorax my dam and she;
But she as far surpasseth Sycorax
As great'st does least.

STEPHANO Is it so brave a lass?

CALIBAN Ay, lord, she will become thy bed, I warrant,
100 And bring thee forth brave brood.

STEPHANO Monster, I will kill this man. His daughter and I will be
king and queen—save our Graces!—and Trinculo and thyself shall
be viceroys. Dost thou like the plot, Trinculo?

TRINCULO Excellent.

105 STEPHANO Give me thy hand. I am sorry I beat thee. But while thou
liv'st, keep a good tongue in thy head.

CALIBAN Within this half hour will he be asleep.
Wilt thou destroy him then?

STEPHANO Ay, on mine honor.

110 ARIEL This will I tell my master.

CALIBAN Thou mak'st me merry. I am full of pleasure.
Let us be jocund. Will you troll the catch* *sing the round*
You taught me but whilere?* *just now*

STEPHANO At thy request, monster, I will do reason,* *anything within reason*
115 any reason. Come on, Trinculo, let us sing.
[*Sings*] Flout 'em and scout* 'em *jeer at*
And scout 'em and flout 'em!
Thought is free.

CALIBAN That's not the tune.

[*Ariel plays the tune on a tabor and pipe.*]

120 STEPHANO What is this same?

TRINCULO This is the tune of our catch played by the picture
of Nobody.

STEPHANO If thou be'st a man, show thyself in thy likeness. If thou
beest a devil, take 't as thou list.

125 TRINCULO O, forgive me my sins!

STEPHANO He that dies pays all debts. I defy thee!
Mercy upon us!

CALIBAN Art thou afeard?

STEPHANO No, monster, not I.

130 CALIBAN Be not afeard. The isle is full of noises,
Sounds and sweet airs that give delight and hurt not.
Sometimes a thousand twangling instruments
Will hum about mine ears, and sometimes voices
That, if I then had waked after long sleep,
135 Will make me sleep again; and then, in dreaming,
The clouds methought would open, and show riches
Ready to drop upon me, that when I waked
I cried to dream again.

STEPHANO This will prove a brave kingdom to me,
140 where I shall have my music for nothing.

CALIBAN When Prospero is destroyed.

STEPHANO That shall be by and by. I remember the story.

TRINCULO The sound is going away. Let's follow it, and after do
our work.

145 STEPHANO Lead, monster. We'll follow. I would I could see this
taborer. He lays it on. Wilt come?

TRINCULO I'll follow, Stephano.

[*They exit.*]

Scene 3.
Another part of the island

[*Enter Alonso, Sebastian, Antonio, Gonzalo, Adrian, Francisco, etc.*]

GONZALO By 'r lakin,* I can go no further, sir. *By our lady*
My old bones aches. Here's a maze trod indeed
Through forthrights and meanders.* By your patience, *straight and winding paths*
I needs must rest me.

5 ALONSO Old lord, I cannot blame thee.
Who am myself attached* with weariness *seized*
To th' dulling of my spirits. Sit down and rest.
Even here I will put off my hope and keep it
No longer for my flatterer. He is drowned
10 Whom thus we stray to find, and the sea mocks
Our frustrate search on land. Well, let him go.

ANTONIO [*Aside to Sebastian*] I am right glad that he's so out of hope.
Do not, for one repulse, forgo the purpose
That you resolved t' effect.

15 SEBASTIAN [*Aside to Antonio*] The next advantage
Will we take throughly.* *thoroughly*

ANTONIO [*Aside to Sebastian*] Let it be tonight;
For, now they are oppressed with travel, they
Will not nor cannot use such vigilance
20 As when they are fresh.

SEBASTIAN [*Aside to Antonio*] I say tonight. No more.

[*Solemn and strange music, and enter Prospero on the top,* invisible.* *upper stage*
Enter several strange Shapes, bringing in a banquet; and dance about
it with gentle actions of salutations; and, inviting the King, etc., to eat,
they depart.]

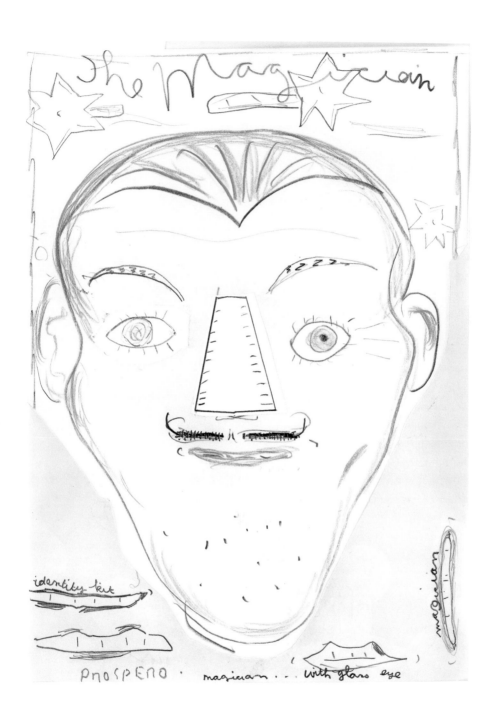

Prospero as Magician

ALONSO What harmony is this? My good friends, hark!

GONZALO Marvelous sweet music!

ALONSO Give us kind keepers,* heavens! What were these? *guardian angels*

25 SEBASTIAN A living drollery!* Now I will believe *puppet show*
That there are unicorns, that in Arabia
There is one tree, the phoenix' throne, one phoenix
At this hour reigning there.

ANTONIO I'll believe both;
30 And what does else want credit,* come to me *lacks credibility*
And I'll be sworn 'tis true. Travelers ne'er did lie,
Though fools at home condemn 'em.

GONZALO If in Naples
I should report this now, would they believe me
35 If I should say I saw such islanders?
(For certes these are people of the island)
Who, though they are of monstrous shape, yet note
Their manners are more gentle, kind, than of
Our human generation you shall find
40 Many, nay, almost any.

PROSPERO [*Aside*] Honest lord,
Thou hast said well, for some of you there present
Are worse than devils.

ALONSO I cannot too much muse* *wonder at*
45 Such shapes, such gesture, and such sound, expressing
(Although they want the use of tongue) a kind
Of excellent dumb discourse.

PROSPERO [*Aside*] Praise in departing.* *Save your praise for the end*

FRANCISCO They vanished strangely.

SEBASTIAN No matter, since
They have left their viands behind, for we have stomachs.
Will 't please you taste of what is here?

ALONSO Not I.

GONZALO Faith, sir, you need not fear. When we were boys,
Who would believe that there were mountaineers
Dewlapped like bulls, whose throats had hanging at 'em
Wallets of flesh? Or that there were such men
Whose heads stood in their breasts? Which now we find
Each putter-out of five for one will bring us
Good warrant of.

ALONSO I will stand to and feed.
Although my last, no matter, since I feel
The best is past. Brother, my lord the Duke,
Stand to, and do as we.

[*Thunder and lightning. Enter Ariel, like a harpy, claps his wings upon
the table, and with a quaint* device the banquet vanishes.*] *ingenious*

ARIEL You are three men of sin, whom destiny—
That hath to* instrument this lower world *as its*
And what is in 't—the never-surfeited sea
Hath caused to belch up you, and on this island,
Where man doth not inhabit, you 'mongst men
Being most unfit to live. I have made you mad;
And even with such-like valor, men hang and drown
Their proper selves.
[*Alonso, Sebastian, and Antonio draw their swords.*]
 You fools, I and my fellows
Are ministers of Fate. The elements
Of whom your swords are tempered* may as well *composed*
Wound the loud winds or with bemocked-at stabs
Kill the still-closing waters as diminish
One dowle* that's in my plume.* My fellow ministers *down | plumage*
Are like invulnerable. If* you could hurt, *Even if*

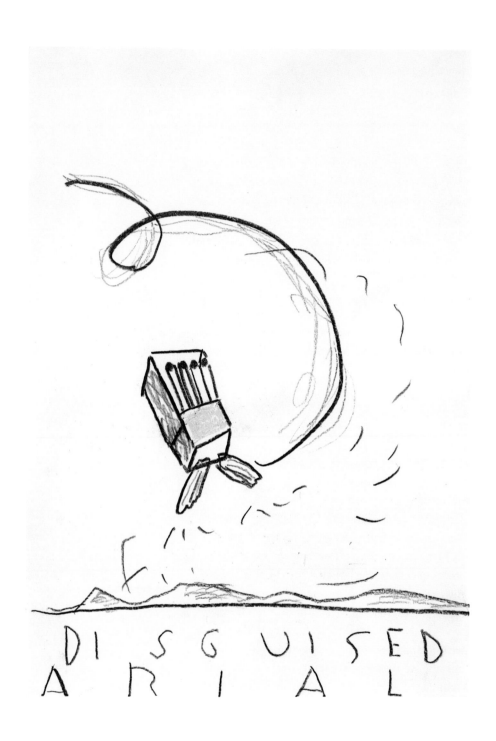

Disguised Arial, Getting Closer

80 Your swords are now too massy* for your strengths *heavy*
And will not be uplifted. But remember
(For that's my business to you) that you three
From Milan did supplant good Prospero,
Exposed unto the sea, which hath requit it,* *avenged the crime*
85 Him and his innocent child, for which foul deed,
The pow'rs, delaying, not forgetting, have
Incensed the seas and shores, yea, all the creatures
Against your peace. Thee of thy son, Alonso,
They have bereft; and do pronounce by me
90 Ling'ring perdition (worse than any death
Can be at once) shall step by step attend
You and your ways, whose wraths to guard you from—
Which here, in this most desolate isle, else falls
Upon your heads—is nothing but heart's sorrow* *repentance*
95 And a clear life ensuing. [*He vanishes in thunder.*]

[*Then, to soft music, enter the Shapes again, and dance, with mocks and
mows, and carrying out the table.*]

PROSPERO Bravely the figure of this harpy hast thou
Performed, my Ariel. A grace it had, devouring.* *making it disappear*
Of my instruction hast thou nothing bated* *omitted*
In what thou hadst to say. So, with good life* *realistic acting*
100 And observation strange,* my meaner ministers* *close observation / inferior agents to Ariel*
Their several kinds* have done. My high charms work, *separate parts*
And these mine enemies are all knit up
In their distractions. They now are in my pow'r;
And in these fits I leave them while I visit
105 Young Ferdinand, whom they suppose is drowned,
And his and mine loved darling. [*He exits, above.*]

GONZALO I' th' name of something holy, sir, why stand you
In this strange stare?

ALONSO O, it is monstrous, monstrous!
110 Methought the billows spoke and told me of it;
The winds did sing it to me, and the thunder,

That deep and dreadful organ pipe, pronounced
The name of Prosper. It did bass* my trespass. *proclaim in deep tones
Therefore my son i' th' ooze is bedded, and
115 I'll seek him deeper than e'er plummet sounded,
And with him there lie mudded. [*He exits.*]

SEBASTIAN But one fiend at a time,
I'll fight their legions o'er.* *one after the other

ANTONIO I'll be thy second.

[*They exit.*]

120 GONZALO All three of them are desperate. Their great guilt,
Like poison given to work a great time after,
Now 'gins to bite the spirits. I do beseech you
That are of suppler joints, follow them swiftly
And hinder them from what this ecstasy* *madness
125 May now provoke them to.

ADRIAN Follow, I pray you.

[*They exit.*]

Act 4.

Scene 1.
In front of Prospero's cell

[*Enter Prospero, Ferdinand, and Miranda.*]

PROSPERO If I have too austerely punished you,
Your compensation makes amends, for I
Have given you here a third of mine own life,
Or that for which I live; who once again
5 I tender to thy hand. All thy vexations
Were but my trials of thy love, and thou
Hast strangely* stood the test. Here afore heaven *wonderfully*
I ratify this my rich gift. O Ferdinand,
Do not smile at me that I boast her off,
10 For thou shalt find she will outstrip all praise
And make it halt* behind her. *limp*

FERDINAND I do believe it
Against an oracle.* *Even if an oracle denied it*

PROSPERO Then, as my gift and thine own acquisition
15 Worthily purchased, take my daughter. But
If thou dost break her virgin-knot before
All sanctimonious* ceremonies may *holy*
With full and holy rite be minist'red,
No sweet aspersion* shall the heavens let fall *blessing*
20 To make this contract grow;* but barren hate, *become fruitful*
Sour-eyed disdain, and discord shall bestrew
The union of your bed with weeds so loathly
That you shall hate it both. Therefore take heed,
As Hymen's lamps shall light you.* *(a good omen)*

25 FERDINAND As I hope
For quiet days, fair issue, and long life,
With such love as 'tis now, the murkiest den,

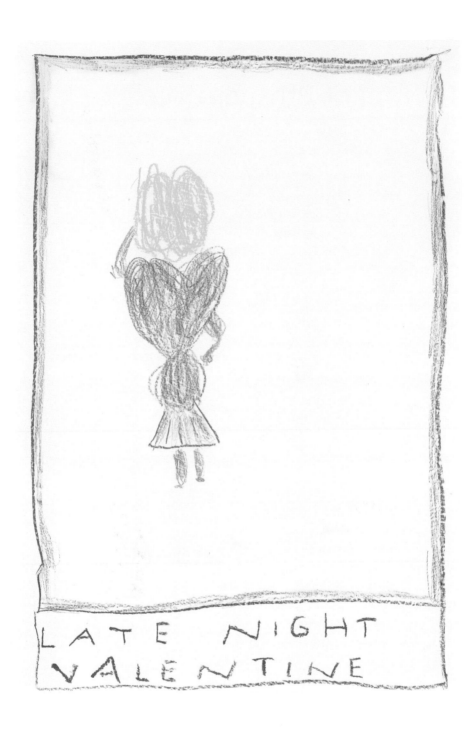

LATE NIGHT VALENTINE

Miranda Aged 14

The most opportune place, the strong'st suggestion
Our worser genius can,* shall never melt *evil spirit can make*
30 Mine honor into lust, to take away
The edge* of that day's celebration *enjoyment*
When I shall think or Phoebus'* steeds are foundered *sun god*
Or night kept chained below.

PROSPERO Fairly spoke.
35 Sit then and talk with her. She is thine own.
What, Ariel, my industrious servant, Ariel!

[*Enter Ariel.*]

ARIEL What would my potent master? Here I am.

PROSPERO Thou and thy meaner fellows your last service
Did worthily perform, and I must use you
40 In such another trick. Go bring the rabble,* *rank and file*
O'er whom I give thee pow'r, here to this place.
Incite them to quick motion, for I must
Bestow upon the eyes of this young couple
Some vanity* of mine art. It is my promise, *show*
45 And they expect it from me.

ARIEL Presently?

PROSPERO Ay, with a twink.

ARIEL Before you can say "Come" and "Go,"
And breathe twice, and cry, "So, so,"
50 Each one, tripping on his toe,
Will be here with mop* and mow.* *gestures | faces*
Do you love me, master? No?

PROSPERO Dearly, my delicate Ariel. Do not approach
Till thou dost hear me call.

55 ARIEL Well; I conceive.* [*He exits.*] *understand*

PROSPERO Look thou be true; do not give dalliance
Too much the rein. The strongest oaths are straw
To th' fire i' th' blood. Be more abstemious,
Or else good night your vow.

60 FERDINAND I warrant you, sir,
The white cold virgin snow upon my heart
Abates the ardor of my liver.* *sexual passion

PROSPERO Well.
Now come, my Ariel. Bring a corollary* *surplus
65 Rather than want a spirit. Appear, and pertly.
No tongue. All eyes. Be silent.

[*Soft music. Enter Iris.**] *Goddess of the rainbow, messenger of the gods

IRIS Ceres, most bounteous lady, thy rich leas* *meadows
Of wheat, rye, barley, fetches, oats, and peas;
Thy turfy mountains, where live nibbling sheep,
70 And flat meads thatched with stover,* them to keep; *a kind of grass
Thy banks with pionèd and twillèd brims,
Which spongy April at thy hest betrims
To make cold nymphs chaste crowns; and thy broom groves,
Whose shadow the dismissèd bachelor loves,
75 Being lasslorn; thy pole-clipped* vineyard, *pruned
And thy sea-marge, sterile and rocky-hard,
Where thou thyself dost air—the queen o' th' sky,* *Juno
Whose wat'ry arch and messenger am I,
Bids thee leave these, and with her sovereign grace,
80 Here on this grass plot, in this very place,
To come and sport. Her peacocks fly amain.* *swiftly
Approach, rich Ceres, her to entertain.

[*Enter Ceres.*]

CERES Hail, many-colored messenger, that ne'er
Dost disobey the wife of Jupiter;
85 Who, with thy saffron wings, upon my flow'rs
Diffusest honey drops, refreshing show'rs,

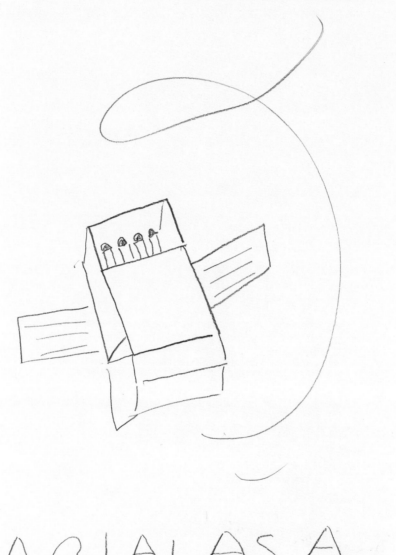

ARIAL AS A
BOX OF MATCHES

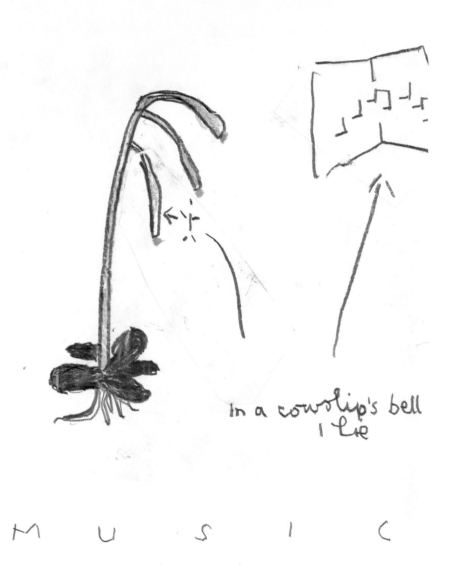

In a cowslip's bell
I lie

M U S I C

And with each end of thy blue bow dost crown
My bosky* acres and my unshrubbed down, *shrubbed
Rich scarf to my proud Earth. Why hath thy queen
90 Summoned me hither to this short-grassed green?

IRIS A contract of true love to celebrate,
And some donation freely to estate* *bestow
On the blest lovers.

CERES Tell me, heavenly bow,
95 If Venus or her son, as thou dost know,
Do now attend the Queen? Since they did plot
The means that dusky Dis* my daughter got, *(Pluto)
Her and her blind boy's scandaled* company *scandalous
I have forsworn.

100 IRIS Of her society
Be not afraid. I met her deity
Cutting the clouds towards Paphos, and her son
Dove-drawn with her. Here thought they to have done
Some wanton charm upon this man and maid,
105 Whose vows are that no bed-right shall be paid
Till Hymen's torch be lighted—but in vain.
Mars's hot minion* is returned again; *(Venus)
Her waspish-headed son* has broke his arrows, *(Cupid)
Swears he will shoot no more, but play with sparrows,
110 And be a boy right out.* *ordinary boy

[Juno descends.]

CERES Highest queen of state,
Great Juno, comes. I know her by her gait.

JUNO How does my bounteous sister? Go with me
To bless this twain, that they may prosperous be
115 And honored in their issue.

[They sing.]

JUNO Honor, riches, marriage blessing,
Long continuance and increasing,
Hourly joys be still* upon you. *ever*
Juno sings her blessings on you.

120 CERES Earth's increase, foison* plenty, *abundance*
Barns and garners never empty,
Vines with clust'ring bunches growing,
Plants with goodly burden bowing;
Spring come to you at the farthest
125 In the very end of harvest.
Scarcity and want shall shun you.
Ceres' blessing so is on you.

FERDINAND This is a most majestic vision, and
Harmonious charmingly. May I be bold
130 To think these spirits?

PROSPERO Spirits, which by mine art
I have from their confines called to enact
My present fancies.

FERDINAND Let me live here ever!
135 So rare a wond'red father and a wise
Makes this place paradise.

[*Juno and Ceres whisper, and send Iris on employment.*]

PROSPERO Sweet now, silence.
Juno and Ceres whisper seriously.
There's something else to do. Hush, and be mute,
140 Or else our spell is marred.

IRIS You nymphs, called Naiads of the windring* brooks, *winding and wandering*
With your sedged crowns and ever-harmless looks,
Leave your crisp* channels and on this green land *rippling*
Answer your summons, Juno does command.
145 Come, temperate nymphs, and help to celebrate

A contract of true love. Be not too late.
[*Enter certain Nymphs.*]
You sunburned sicklemen, of August weary,
Come hither from the furrow and be merry.
Make holiday: your rye-straw hats put on,
150 And these fresh nymphs encounter every one
In country footing.*

[*Enter certain Reapers, properly habited. They join with the Nymphs in
a graceful dance, towards the end whereof Prospero starts suddenly and
speaks. After which, to a strange, hollow, and confused noise, the spirits
heavily* vanish.*]

PROSPERO [*Aside*] I had forgot that foul conspiracy
Of the beast Caliban and his confederates
Against my life. The minute of their plot
155 Is almost come. [*To the Spirits*] Well done. Avoid.* No more.

FERDINAND This is strange. Your father's in some passion
That works him strongly.

MIRANDA Never till this day
Saw I him touched with anger, so distempered.*

160 PROSPERO You do look, my son, in a movèd sort,*

As if you were dismayed. Be cheerful, sir.
Our revels now are ended. These our actors,
As I foretold you, were all spirits and
Are melted into air, into thin air;
165 And like the baseless fabric of this vision,
The cloud-capped towers, the gorgeous palaces,
The solemn temples, the great globe itself,
Yea, all which it inherit,* shall dissolve,

And, like this insubstantial pageant faded,
170 Leave not a rack* behind. We are such stuff

As dreams are made on, and our little life
Is rounded with a sleep. Sir, I am vexed.
Bear with my weakness. My old brain is troubled.

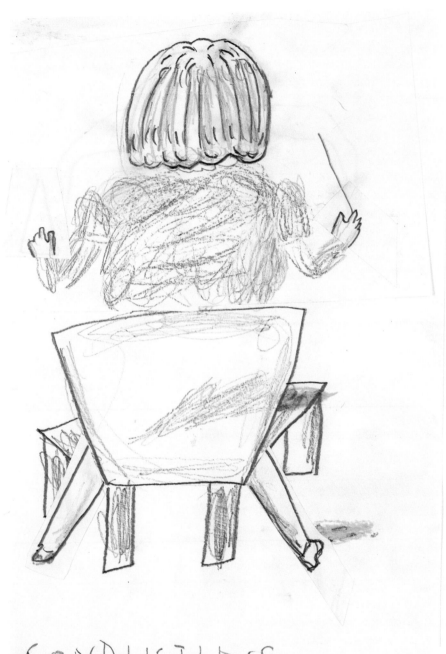

CONDUCTING,
FROM THE
BACK, YOUNG MIRANDA

Miranda Aged 13

Be not disturbed with my infirmity.
175 If you be pleased, retire into my cell
And there repose. A turn or two I'll walk
To still my beating mind.

FERDINAND AND MIRANDA We wish your peace. [*They exit.*]

[*Enter Ariel.*]

PROSPERO Come with a thought. I thank thee, Ariel. Come.

180 ARIEL Thy thoughts I cleave to. What's thy pleasure?

PROSPERO Spirit,
We must prepare to meet with Caliban.

ARIEL Ay, my commander. When I presented Ceres,
I thought to have told thee of it, but I feared
185 Lest I might anger thee.

PROSPERO Say again, where didst thou leave these varlets?* *ruffians*

ARIEL I told you, sir, they were red-hot with drinking,
So full of valor that they smote the air
For breathing in their faces, beat the ground
190 For kissing of their feet; yet always bending
Towards their project. Then I beat my tabor,
At which, like unbacked* colts, they pricked their ears, *unbroken*
Advanced* their eyelids, lifted up their noses *Lifted*
As they smelt music. So I charmed their ears
195 That, calf-like, they my lowing followed through
Toothed briers, sharp furzes, pricking goss,* and thorns, *gorse*
Which ent'red their frail shins. At last I left them
I' th' filthy-mantled pool* beyond your cell, *covered in scum*
There dancing up to th' chins, that the foul lake
200 O'erstunk their feet.

PROSPERO This was well done, my bird.

Thy shape invisible retain thou still.
The trumpery* in my house, go bring it hither *apparel*
For stale* to catch these thieves. *decoy*

205 ARIEL I go, I go. [*He exits.*]

PROSPERO A devil, a born devil, on whose nature
Nurture can never stick; on whom my pains,
Humanely taken, all, all lost, quite lost!
And as with age his body uglier grows,
210 So his mind cankers. I will plague them all
Even to roaring.
[*Enter Ariel, loaden with glistering apparel, etc.*]
 Come, hang them on this line.* *lime tree*

[*Enter Caliban, Stephano, and Trinculo, all wet, as Prospero and Ariel
look on.*]

CALIBAN Pray you, tread softly, that the blind mole may not
Hear a footfall. We now are near his cell.

215 STEPHANO Monster, your fairy, which you say is a harmless fairy,
has done little better than played the Jack* with us. *knave*

TRINCULO Monster, I do smell all horse piss, at which my nose is in
great indignation.

STEPHANO So is mine. Do you hear, monster? If I should take
220 a displeasure against you, look you—

TRINCULO Thou wert but a lost monster.

CALIBAN Good my lord, give me thy favor still.
Be patient, for the prize I'll bring thee to
Shall hoodwink* this mischance. Therefore speak softly. *cover over*
225 All's hushed as midnight yet.

TRINCULO Ay, but to lose our bottles in the pool!

110

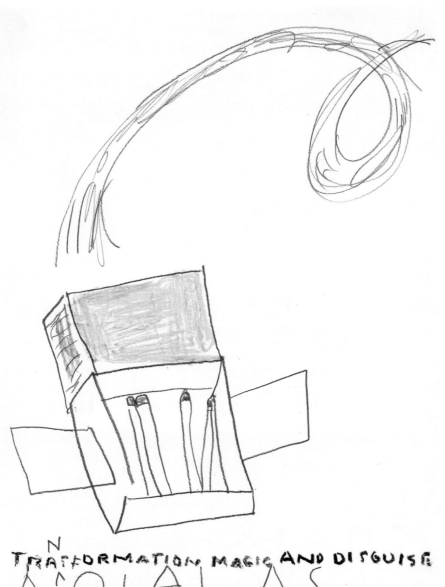

TRANSFORMATION MAGIC AND DISGUISE
ARIAL AS
A BOX OF MATCHES

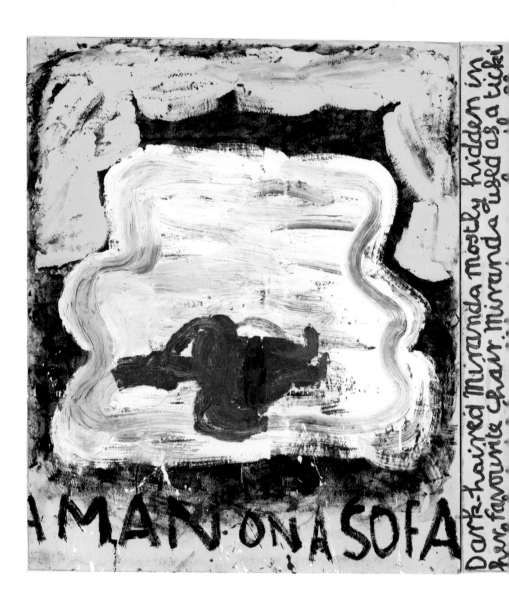

Dark-haired Miranda mostly hidden in here favourite chair. Miranda used as a ticki...

HMAN ON A SOFA

Miranda, Twice and Caliban

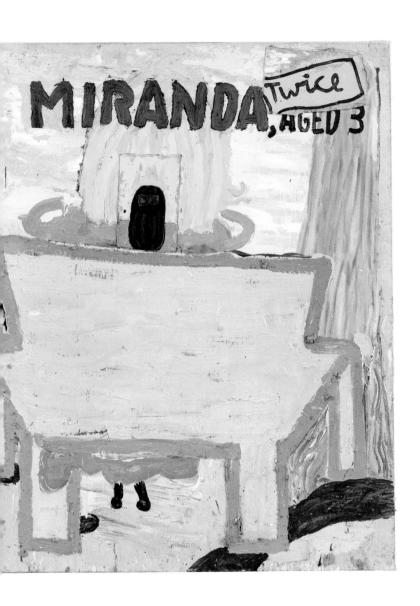

MIRANDA, *twice* AGED 3

STEPHANO There is not only disgrace and dishonor in that, monster, but an infinite loss.

TRINCULO That's more to me than my wetting. Yet this is your
230 harmless fairy, monster.

STEPHANO I will fetch off my bottle, though I be o'er ears for my labor.

CALIBAN Prithee, my king, be quiet. Seest thou here?
This is the mouth o' th' cell. No noise, and enter.
Do that good mischief which may make this island
235 Thine own forever, and I, thy Caliban,
For aye thy footlicker.

STEPHANO Give me thy hand. I do begin to have bloody thoughts.

TRINCULO O King Stephano! O peer! O worthy Stephano, look what
a wardrobe here is for thee!

240 CALIBAN Let it alone, thou fool. It is but trash.

TRINCULO O, ho, monster, we know what belongs to a frippery.* *old-clothes shop
O King Stephano!

STEPHANO Put off that gown, Trinculo. By this hand, I'll have
that gown.

245 TRINCULO Thy Grace shall have it.

CALIBAN The dropsy drown this fool! What do you mean
To dote thus on such luggage?* Let 't alone, *junk
And do the murder first. If he awake,
From toe to crown he'll fill our skins with pinches,
250 Make us strange stuff.

STEPHANO Be you quiet, monster. Mistress line, is not this my jerkin?
[He takes a jacket from the tree.] Now is the jerkin under the line. Now,
jerkin, you are like to lose your hair and prove a bald jerkin.

TRINCULO Do, do. We steal by line and level,* and 't like* *according to the rule | if it please*
255 your Grace.

STEPHANO I thank thee for that jest. Here's a garment for 't.
Wit shall not go unrewarded while I am king of this country.
"Steal by line and level" is an excellent pass of pate.* There's *sally of wit*
another garment for 't.

260 TRINCULO Monster, come, put some lime upon your fingers,
and away with the rest.

CALIBAN I will have none on 't. We shall lose our time
And all be turned to barnacles or to apes
With foreheads villainous low.

265 STEPHANO Monster, lay to your fingers. Help to bear this away
where my hogshead of wine is, or I'll turn you out of my kingdom.
Go to, carry this.

TRINCULO And this.

STEPHANO Ay, and this.

[*A noise of hunters heard. Enter divers Spirits in shape of dogs and hounds,
hunting them about, Prospero and Ariel setting them on.*]

270 PROSPERO Hey, Mountain, hey!

ARIEL Silver! There it goes, Silver!

PROSPERO Fury, Fury! There, Tyrant, there! Hark, hark!
[*Caliban, Stephano, and Trinculo are driven off.*]
Go, charge my goblins that they grind their joints
With dry convulsions, shorten up their sinews
275 With agèd cramps, and more pinch-spotted make them
Than pard or cat o' mountain.* *leopard or catamount*

ARIEL Hark, they roar!

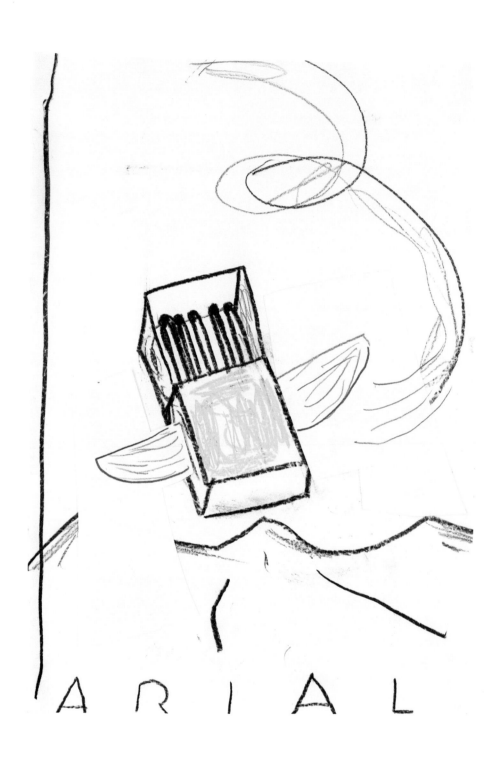

ARIAL

PROSPERO Let them be hunted soundly. At this hour
Lies at my mercy all mine enemies.
280 Shortly shall all my labors end, and thou
Shalt have the air at freedom. For a little
Follow and do me service.

[*They exit.*]

Act 5.

Scene 1.
In front of Prospero's cell

[*Enter Prospero in his magic robes, and Ariel.*]

PROSPERO Now does my project gather to a head.
My charms crack not, my spirits obey, and time
Goes upright with his carriage.* How's the day? *time's burden is light*

ARIEL On the sixth hour, at which time, my lord,
5 You said our work should cease.

PROSPERO I did say so
When first I raised the tempest. Say, my spirit,
How fares the King and 's followers?

ARIEL Confined together
10 In the same fashion as you gave in charge,
Just as you left them; all prisoners, sir,
In the line grove which weather-fends* your cell. *protects*
They cannot budge till your release. The King,
His brother, and yours abide all three distracted,
15 And the remainder mourning over them,
Brimful of sorrow and dismay; but chiefly
Him that you termed, sir, the good old Lord Gonzalo.
His tears runs down his beard like winter's drops
From eaves of reeds.* Your charm so strongly works 'em *thatched roof*
20 That if you now beheld them, your affections
Would become tender.

PROSPERO Dost thou think so, spirit?

ARIEL Mine would, sir, were I human.

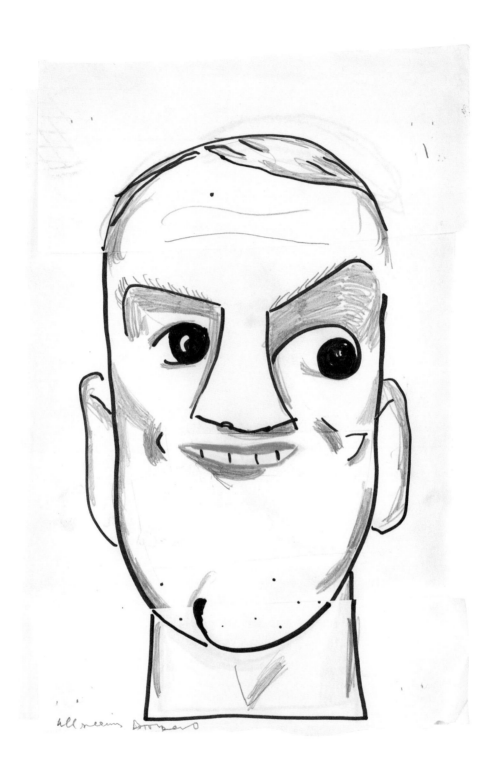

Prospero as "Governor"

PROSPERO And mine shall.
25 Hast thou, which art but air, a touch, a feeling
 Of their afflictions, and shall not myself,
 One of their kind, that relish all as sharply
 Passion as they, be kindlier moved than thou art?
 Though with their high wrongs I am struck to th' quick,
30 Yet with my nobler reason 'gainst my fury
 Do I take part. The rarer action is
 In virtue than in vengeance. They being penitent,
 The sole drift of my purpose doth extend
 Not a frown further. Go, release them, Ariel.
35 My charms I'll break, their senses I'll restore,
 And they shall be themselves.

ARIEL I'll fetch them, sir. [*He exits.*]

PROSPERO You elves of hills, brooks, standing lakes, and groves,
 And you that on the sands with printless foot
40 Do chase the ebbing Neptune, and do fly him* *fly with him*
 When he comes back; you demi-puppets* that *fairies*
 By moonshine do the green sour ringlets make,
 Whereof the ewe not bites; and you whose pastime
 Is to make midnight mushrumps,* that rejoice *mushrooms*
45 To hear the solemn curfew; by whose aid
 (Weak masters* though you be) I have bedimmed *forces*
 The noontide sun, called forth the mutinous winds,
 And 'twixt the green sea and the azured vault
 Set roaring war; to the dread rattling thunder
50 Have I given fire, and rifted Jove's stout oak
 With his own bolt; the strong-based promontory
 Have I made shake, and by the spurs* plucked up *roots*
 The pine and cedar; graves at my command
 Have waked their sleepers, oped, and let 'em forth
55 By my so potent art. But this rough magic
 I here abjure, and when I have required* *asked for*
 Some heavenly music (which even now I do)
 To work mine end upon their senses that
 This airy charm is for, I'll break my staff,

60 Bury it certain fathoms in the earth,
And deeper than did ever plummet sound
I'll drown my book.
[*Solemn music. Here enters Ariel before; then Alonso with a frantic*
gesture, attended by Gonzalo; Sebastian and Antonio in like manner
attended by Adrian and Francisco. They all enter the circle which
Prospero had made, and there stand charmed; which Prospero
observing, speaks.]
A solemn air, and* the best comforter *which is*
To an unsettled fancy, cure thy brains,
65 Now useless, boiled within thy skull. There stand,
For you are spell-stopped.
Holy Gonzalo, honorable man,
Mine eyes, ev'n sociable to the show of thine,
Fall fellowly drops.* The charm dissolves apace, *tears*
70 And as the morning steals upon the night,
Melting the darkness, so their rising senses
Begin to chase the ignorant fumes that mantle
Their clearer reason. O good Gonzalo,
My true preserver and a loyal sir
75 To him thou follow'st, I will pay thy graces
Home,* both in word and deed. Most cruelly *Repay thy favors*
Didst thou, Alonso, use me and my daughter.
Thy brother was a furtherer in the act.
Thou art pinched for 't now, Sebastian. Flesh and blood,
80 You, brother mine, that entertained ambition,
Expelled remorse* and nature,* whom, with Sebastian *pity / natural feeling*
(Whose inward pinches therefore are most strong),
Would here have killed your king, I do forgive thee,
Unnatural though thou art. Their understanding
85 Begins to swell, and the approaching tide
Will shortly fill the reasonable shore
That now lies foul and muddy. Not one of them
That yet looks on me or would know me. Ariel,
Fetch me the hat and rapier in my cell.
90 I will discase* me and myself present *disrobe*
As I was sometime Milan. Quickly, spirit,
Thou shalt ere long be free.

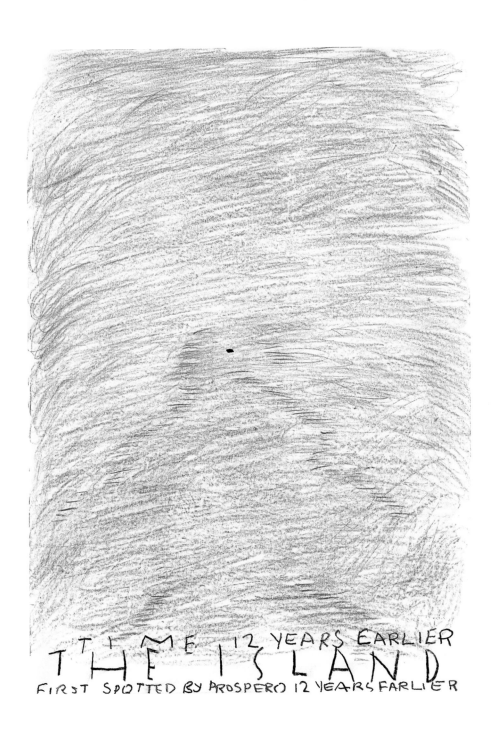

TIME 12 YEARS EARLIER
THE ISLAND
FIRST SPOTTED BY PROSPERO 12 YEARS EARLIER

[*Ariel exits and returns immediately. He sings and helps to attire him.*]

ARIEL Where the bee sucks, there suck I.
In a cowslip's bell I lie.
95 There I couch when owls do cry.
On the bat's back I do fly
After summer merrily.
Merrily, merrily shall I live now
Under the blossom that hangs on the bow.

100 PROSPERO Why, that's my dainty Ariel. I shall miss thee
But yet thou shalt have freedom. So, so, so.
To the King's ship, invisible as thou art.
There shalt thou find the mariners asleep
Under the hatches. The master and the boatswain
105 Being awake, enforce them to this place,
And presently,* I prithee. *immediately*

ARIEL I drink the air before me, and return
Or ere your pulse twice beat. [*He exits.*]

GONZALO All torment, trouble, wonder, and amazement
110 Inhabits here. Some heavenly power guide us
Out of this fearful country!

PROSPERO Behold, sir King,
The wrongèd Duke of Milan, Prospero.
For more assurance that a living prince
115 Does now speak to thee, I embrace thy body,
And to thee and thy company I bid
A hearty welcome.

ALONSO Whe'r* thou be'st he or no, *Whether*
Or some enchanted trifle* to abuse me, *apparition*
120 As late I have been, I not know. Thy pulse
Beats as of flesh and blood; and since I saw thee,
Th' affliction of my mind amends, with which
I fear a madness held me. This must crave* *require*

(And if this be* at all) a most strange story. *this is happening*
125 Thy dukedom I resign, and do entreat
Thou pardon me my wrongs. But how should Prospero
Be living and be here?

PROSPERO First, noble friend,
Let me embrace thine age, whose honor cannot
130 Be measured or confined.

GONZALO Whether this be
Or be not, I'll not swear.

PROSPERO You do yet taste
Some subtleties* o' th' isle, that will not let you *deceptions*
135 Believe things certain. Welcome, my friends all.
[*Aside to Sebastian and Antonio*] But you, my brace of lords,
 were I so minded,
I here could pluck* his Highness' frown upon you *pull down*
And justify* you traitors. At this time *prove*
140 I will tell no tales.

SEBASTIAN [*Aside*] The devil speaks in him.

PROSPERO No.
For you, most wicked sir, whom to call brother
Would even infect my mouth, I do forgive
145 Thy rankest fault, all of them, and require
My dukedom of thee, which perforce I know
Thou must restore.

ALONSO If thou beest Prospero,
Give us particulars of thy preservation,
150 How thou hast met us here, whom three hours since
Were wracked upon this shore, where I have lost
(How sharp the point of this remembrance is!)
My dear son Ferdinand.

PROSPERO I am woe* for 't, sir. *sorry*

155 ALONSO Irreparable is the loss, and patience
Says it is past her cure.

PROSPERO I rather think
You have not sought her help, of whose soft grace,
For the like loss, I have her sovereign aid
160 And rest myself content.

ALONSO You the like loss?

PROSPERO As great to me as late,* and supportable *as your loss*
To make the dear loss have I means much weaker
Than you may call to comfort you, for I
165 Have lost my daughter.

ALONSO A daughter?
O heavens, that they were living both in Naples,
The King and Queen there! That they were, I wish
Myself were mudded in that oozy bed
170 Where my son lies! When did you lose your daughter?

PROSPERO In this last tempest. I perceive these lords
At this encounter do so much admire* *wonder*
That they devour their reason, and scarce think
Their eyes do offices* of truth, their words *perform services*
175 Are natural breath. But howsoev'r you have
Been justled from your senses, know for certain
That I am Prospero and that very duke
Which was thrust forth of Milan, who most strangely
Upon this shore, where you were wracked, was landed
180 To be the lord on 't. No more yet of this.
For 'tis a chronicle of day by day,
Not a relation for a breakfast, nor
Befitting this first meeting. Welcome, sir.
This cell's my court. Here have I few attendants,
185 And subjects none abroad.* Pray you, look in. *i.e., on the island*
My dukedom since you have given me again,
I will requite you with as good a thing,

At least bring forth a wonder to content ye
As much as me my dukedom.

[*Here Prospero discovers* Ferdinand *and* Miranda, *playing at chess.*] *reveals*

190 MIRANDA Sweet lord, you play me false.

FERDINAND No, my dearest love,
I would not for the world.

MIRANDA Yes, for a score of kingdoms you should wrangle,
And I would call it fair play.

195 ALONSO If this prove
A vision of the island, one dear son
Shall I twice lose.

SEBASTIAN A most high miracle!

FERDINAND Though the seas threaten, they are merciful.
200 I have cursed them without cause. [*He kneels.*]

ALONSO Now, all the blessings
Of a glad father compass thee about!
Arise, and say how thou cam'st here.

MIRANDA O wonder!
205 How many goodly creatures are there here!
How beauteous mankind is! O, brave new world
That has such people in 't!

PROSPERO 'Tis new to thee.

ALONSO What is this maid with whom thou wast at play?
210 Your eld'st* acquaintance cannot be three hours. *longest*
Is she the goddess that hath severed us
And brought us thus together?

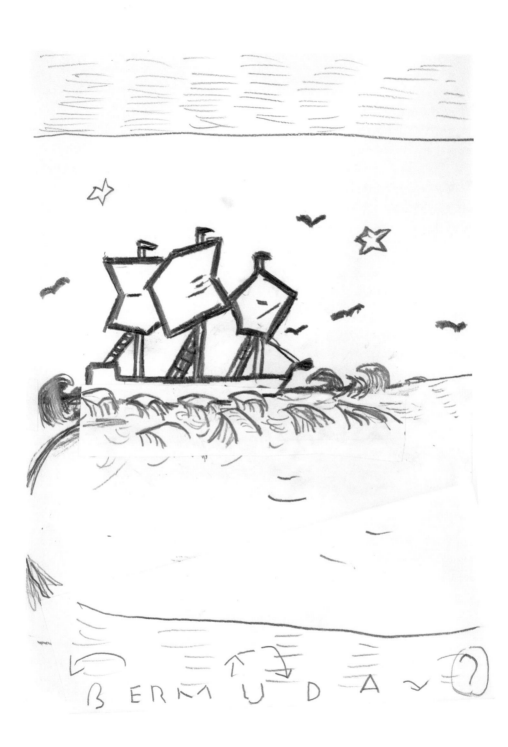

Shipwreck, Bermuda

FERDINAND Sir, she is mortal,
But by immortal providence she's mine.
215 I chose her when I could not ask my father
For his advice, nor thought I had one. She
Is daughter to this famous Duke of Milan,
Of whom so often I have heard renown,
But never saw before, of whom I have
220 Received a second life; and second father
This lady makes him to me.

ALONSO I am hers.
But, O, how oddly will it sound that I
Must ask my child forgiveness!

225 PROSPERO There, sir, stop.
Let us not burden our remembrances with
A heaviness that's gone.

GONZALO I have inly wept
Or should have spoke ere this. Look down, you gods,
230 And on this couple drop a blessèd crown!
For it is you that have chalked forth the way
Which brought us hither.

ALONSO I say amen, Gonzalo.

GONZALO Was Milan thrust from Milan, that his issue
235 Should become kings of Naples? O, rejoice
Beyond a common joy, and set it down
With gold on lasting pillars. In one voyage
Did Claribel her husband find at Tunis,
And Ferdinand, her brother, found a wife
240 Where he himself was lost; Prospero his dukedom
In a poor isle; and all of us ourselves
When no man was his own.

ALONSO [*To Ferdinand and Miranda*] Give me your hands.
Let grief and sorrow still* embrace his heart *forever*
245 That doth not wish you joy.

GONZALO Be it so! Amen!

[*Enter Ariel, with the Master and Boatswain amazedly following.*]

O, look, sir, look, sir, here is more of us!

I prophesied if a gallows were on land,

This fellow could not drown. Now, blasphemy,

250 That swear'st grace o'erboard, not an oath on shore?

Hast thou no mouth by land? What is the news?

BOATSWAIN The best news is that we have safely found

Our king and company. The next, our ship,

Which, but three glasses* since, we gave out split, *hours*

255 Is tight and yare* and bravely rigged as when *shipshape*

We first put out to sea.

ARIEL [*Aside to Prospero*] Sir, all this service

Have I done since I went.

PROSPERO [*Aside to Ariel*] My tricksy* spirit! *ingenious*

260 ALONSO These are not natural events. They strengthen

From strange to stranger.—Say, how came you hither?

BOATSWAIN If I did think, sir, I were well awake,

I'd strive to tell you. We were dead of sleep

And (how, we know not) all clapped under hatches,

265 Where, but even now, with strange and several noises

Of roaring, shrieking, howling, jingling chains,

And moe* diversity of sounds, all horrible, *more*

We were awaked, straightway at liberty,

Where we, in all her trim, freshly beheld

270 Our royal, good, and gallant ship, our master

Cap'ring to eye* her. On a trice, so please you, *Dancing to see*

Even in a dream were we divided from them

And were brought moping* hither. *in a daze*

ARIEL [*Aside to Prospero*] Was 't well done?

275 PROSPERO [*Aside to Ariel*] Bravely, my diligence.

Thou shalt be free.

ALONSO This is as strange a maze as e'er men trod,
And there is in this business more than nature
Was ever conduct* of. Some oracle *conductor*
280 Must rectify our knowledge.

PROSPERO Sir, my liege,
Do not infest* your mind with beating on *tease*
The strangeness of this business. At picked leisure,
Which shall be shortly, single I'll resolve you,
285 Which to you shall seem probable, of every
These happened accidents;* till when, be cheerful *incidents*
And think of each thing well. [*Aside to Ariel*] Come hither, spirit;
Set Caliban and his companions free.
Untie the spell. [*Ariel exits.*] How fares my gracious sir?
290 There are yet missing of your company
Some few odd lads that you remember not.

[*Enter Ariel, driving in Caliban, Stephano, and Trinculo in their stolen
apparel.*]

STEPHANO Every man shift for all the rest, and let no man take care
for himself, for all is but fortune. Coragio,* bully monster, coragio! *Courage*

TRINCULO If these be true spies which I wear in my head, here's
295 a goodly sight.

CALIBAN O Setebos,* these be brave spirits indeed! *God of Caliban's mother*
How fine my master is! I am afraid
He will chastise me.

SEBASTIAN Ha, ha!
300 What things are these, my Lord Antonio?
Will money buy 'em?

ANTONIO Very like. One of them
Is a plain fish and no doubt marketable.

PROSPERO Mark but the badges of these men, my lords,
305 Then say if they be true.* This misshapen knave, *honest*

His mother was a witch, and one so strong
That could control the moon, make flows and ebbs,
And deal in her command without* her power. *beyond
These three have robbed me, and this demi-devil,
310 For he's a bastard one, had plotted with them
To take my life. Two of these fellows you
Must know and own. This thing of darkness I
Acknowledge mine.

CALIBAN I shall be pinched to death.

315 ALONSO Is not this Stephano, my drunken butler?

SEBASTIAN He is drunk now. Where had he wine?

ALONSO And Trinculo is reeling ripe. Where should they
Find this grand liquor that hath gilded 'em?
How cam'st thou in this pickle?

320 TRINCULO I have been in such a pickle since I saw you last that I fear
me will never out of my bones. I shall not fear flyblowing.* *pickling meat

SEBASTIAN Why, how now, Stephano?

STEPHANO O, touch me not! I am not Stephano, but a cramp.

PROSPERO You'd be king o' the isle, sirrah?

325 STEPHANO I should have been a sore* one, then. *tyrannical

ALONSO This is as strange a thing as e'er I looked on.

PROSPERO He is as disproportioned in his manners
As in his shape. Go, sirrah, to my cell.
Take with you your companions. As you look
330 To have my pardon, trim it handsomely.

CALIBAN Ay, that I will, and I'll be wise hereafter
And seek for grace. What a thrice-double ass
Was I to take this drunkard for a god,
And worship this dull fool!

335 PROSPERO Go to, away!

ALONSO Hence, and bestow your luggage where you found it.

SEBASTIAN Or stole it, rather.

[Caliban, Stephano, and Trinculo exit.]

PROSPERO Sir, I invite your Highness and your train
To my poor cell, where you shall take your rest
340 For this one night, which part of it I'll waste* spend
With such discourse as, I not doubt, shall make it
Go quick away: the story of my life
And the particular accidents* gone by incidents
Since I came to this isle. And in the morn
345 I'll bring you to your ship, and so to Naples,
Where I have hope to see the nuptial
Of these our dear-beloved solemnizèd,
And thence retire me to my Milan, where
Every third thought shall be my grave.

350 ALONSO I long
To hear the story of your life, which must
Take* the ear strangely. Captivate

PROSPERO I'll deliver* all, tell
And promise you calm seas, auspicious gales,
355 And sail so expeditious that shall catch
Your royal fleet far off. [Aside to Ariel] My Ariel, chick,
That is thy charge. Then to the elements
Be free, and fare thou well. [To the others] Please you, draw near.

[They all exit.]

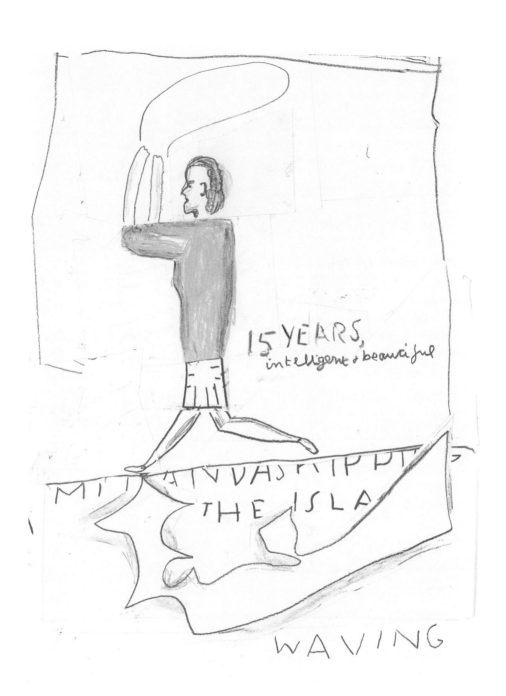

15 YEARS,
intelligent & beautiful

MI ANUASKIPP
THE ISLA

WAVING

Miranda, Waving

Epilogue
Spoken by Prospero

Now my charms are all o'erthrown,
And what strength I have 's mine own,
Which is most faint. Now 'tis true
I must be here confined by you,
5 Or sent to Naples. Let me not,
Since I have my dukedom got
And pardoned the deceiver, dwell
In this bare island by your spell,
But release me from my bands* *bonds*
10 With the help of your good hands.* *applause*
Gentle breath* of yours my sails *Favorable comment*
Must fill, or else my project fails,
Which was to please. Now I want* *lack*
Spirits to enforce, art to enchant,
15 And my ending is despair,
Unless I be relieved by prayer,* *this petition*
Which pierces so that it assaults
Mercy itself, and frees all faults.
As you from crimes would pardoned be,
20 Let your indulgence set me free.

[*He exits.*]

List
of Works

All works from the series
Drawings from the Tempest

Arial About to Turn into a Matchbox,
2018
Pencil, colored pencil, and collage
on paper
12 ¼ × 8 ½ inches
31 × 21.5 cm
p. 43

Arial & Rough Sea, 2018
Colored pencil on paper
11 ⅝ × 8 ⅛ inches
29.5 × 20.5 cm
p. 116

Arial as a Box of Matches, 2018
Colored pencil on paper
11 ⅝ × 8 ¼ inches
29.5 × 21 cm
p. 111

Arial as a Butterfly, 2020
Colored pencil, pencil, and collage
on paper
11 ¾ × 8 ¼ inches
30 × 21 cm
p. 85

Arial as a Matchbox, 2018
Pencil on paper
11 ⅝ × 8 ¼ inches
29.5 × 21 cm
p. 103

Arial as a Spirit, 2018
Pencil, biro, and collage on paper
11 ¾ × 8 ¼ inches
29.7 × 21 cm
p. 35

Caliban as a Viable and Practical Man,
2018
Colored pencil on paper
11 ⅝ × 8 ¼ inches
29.5 × 21 cm
p. 69

Disguised Arial, Getting Closer, 2018
Colored pencil on paper
11 ⅝ × 8 ¼ inches
29.5 × 21 cm
p. 94

Ferdinand, 2020
Colored pencil and pencil on paper
11 ¾ × 8 ¼ inches
29.7 × 21 cm
p. 48

Full Fathom 5 Thy Father Lies, 2020
Marker, biro, pencil, and collage
on paper
12 ⅛ × 8 ⅜ inches
30.8 × 21.4 cm
p. 45

In a Cowslip's Bell I Lie, 2020
Colored pencil, pencil, and collage
on paper
12 ⅛ × 8 ½ inches
30.7 × 21.5 cm
p. 1

In a Cowslip's Bell with Music, 2020
Colored pencil, pencil, and collage
on paper
11 ¾ × 8 ¼ inches
29.7 × 21 cm
p. 104

The Island, Green, 2021
Colored pencil, pencil, and collage
on paper
11 ¾ × 8 ¼ inches
29.7 × 21 cm
p. 56

Magic & Intuition, 2018
Colored pencil, biro, and collage
on paper
12 ½ × 8 ¼ inches
31.7 × 21 cm
p. 5

Miranda, 2018
Colored pencil, marker, and collage
on paper
11 ¾ × 8 ½ inches
30 × 21.5 cm
p. 78

Miranda Aged 3, 2021
Colored pencil, pencil, and collage
on paper
11 ⅝ × 8 ½ inches
29.6 × 21.7 cm
p. 26

Miranda Aged 4, 2020
Colored pencil, pencil, and collage
on paper
12 ⅛ × 8 ⅜ inches
30.7 × 21.4 cm
p. 27

Miranda Aged 13, 2021
Colored pencil, pencil, and collage
on paper
13 ⅛ × 8 ½ inches
34 × 21.9 cm
p. 108

Miranda Aged 14, 2020
Colored pencil on paper
11 ¾ × 8 ¼ inches
29.7 × 21 cm
p. 100

Miranda on a Green Chair, 2021
Colored pencil on paper
11 ¾ × 8 ¼ inches
29.7 × 21 cm
p. 28

Miranda, Twice and Caliban, 2021
Oil on canvas
72 × 131 ¼ inches
183 × 333.5 cm
pp. 112–113

Miranda, Waving, 2018
Colored pencil and collage on paper
11 ¾ × 8 ¾ inches
30 × 22.2 cm
p. 134

Miranda with 2 Spares, 2021
Colored pencil, pencil, and collage
on paper
11 ⅞ × 8 ⅜ inches
30.2 × 21.2 cm
p. 81

Miranda with Yellow Hair Blowing Left,
2021
Colored pencil, pencil, and collage
on paper
11 ¾ × 8 ¼ inches
29.7 × 21 cm
p. 25

Place; The Island, Blue, 2020
Colored pencil and pencil on paper
11 ¾ × 8 ¼ inches
29.7 × 21 cm
p. 123

Place; Map, 2020
Colored pencil, pencil, and collage
on paper
11 ¾ × 8 ½ inches
29.8 × 21.5 cm
p. 20

Prospero as "Governor," 2002
Colored pencil, pencil, marker,
and collage on paper
12 ¾ × 8 ½ inches
32.5 × 21.7 cm
p. 120

Prospero as Magician, 2018
Colored pencil, biro, and collage
on paper
11 ¾ × 8 ⅜ inches
29.8 × 21.2 cm
p. 91

Shipwreck, Bermuda, 2018
Colored pencil and collage on paper
12 × 8 ⅝ inches
30.5 × 22 cm
p. 128

Sycorax, Caliban's Mother, Close Up, 2018
Colored pencil on paper
11 ⅜ × 8 ¼ inches
29 × 21 cm
p. 38

Acknowl-
edgments

David Zwirner wishes to thank Rose Wylie, without whom this volume would not have been possible, as well as Rodolphe von Hofmannsthal for his collaboration and support. Thanks are due to Katie Kitamura for her thoughtful, illuminating, and enchanting introduction.

Many thanks to Jari Juhani Lager, William Gustafsson, and Hazel Shepley and Frankie Shepley from Rose's studio. For their work on this volume, we are grateful to Anna Arca, Claire Bidwell, Spike Blake, Sergio Brunelli, Stephanie Cavalcanti, Sara Chan, Angela Choon, Andrew Crichton, Anna Drozda, Fabio Ferrandini, Zeno Ferrandini, Rosario Gallo, Doro Globus, Elizabeth Gordon, Will Hine, Jane Hyne, Susie Larouci, Davide Meneghello, Jessica Palinski, Mari Perina, Sarah Schrauwen, Tyler Short, Molly Stein, Jules Thomson, Joey Young, and Lucas Zwirner.

The Tempest
William Shakespeare × Rose Wylie

From the series *Seeing Shakespeare*

David Zwirner Books
529 West 20th Street, 2nd Floor
New York, New York 10011
+1 212 727 2070
davidzwirnerbooks.com

Managing Director Doro Globus
Editorial Director Lucas Zwirner
Sales and Distribution Manager
Molly Stein

Editor Elizabeth Gordon
Proofreader Anna Drozda

Design Sarah Schrauwen
Head of Production Jules Thomson
Production Manager Claire Bidwell
Color Separations Altaimage
Printing VeronaLibri, Verona

Typeface Freight Text
Paper Multi Offset, 120 gsm

Publication © 2022 David Zwirner Books
"The Inhabitants" © 2022 Katie Kitamura
All artwork © 2022 Rose Wylie

All photography by Anna Arca

Distributed in the United States
and Canada by
Simon & Schuster, Inc.
1230 Avenue of the Americas
New York, New York 10020
simonandschuster.com

Distributed outside the United States
and Canada by
Thames & Hudson, Ltd.
181A High Holborn
London WC1V 7QX
thamesandhudson.com

ISBN 978-1-64423-061-9
Library of Congress Control Number:
2021924640

Printed in Italy

Cover *Prospero as "Governor,"*
2002 (detail)

A Note on the Text
This edition of *The Tempest* is based
directly on the First Folio of 1623.
Spelling and punctuation have been
standardized, but certain forms of words
remain as in the original if they sound
distinctly different from modern forms,
such as *an* for *if*.